IMAGES
of America

GATES

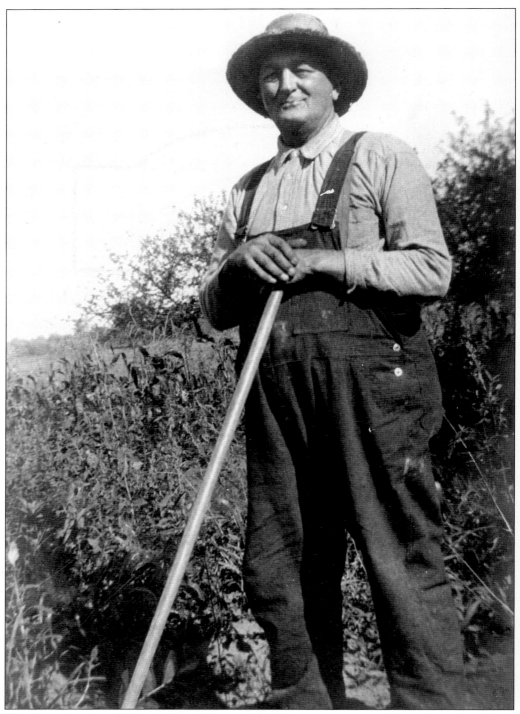

The determination of Aloysius Vogel (born *c.* 1860) is representative of the early settlers. Their pioneer spirit and resolve transcended the hardships of a new territory and established the town of Gates in the western New York wilderness.

IMAGES
of America
GATES

Gates Historical Society

ARCADIA

Copyright © 2005 by Gates Historical Society
ISBN 0-7385-3721-7

First published 2005

Published by Arcadia Publishing,
Charleston SC, Chicago IL, Portsmouth NH, San Francisco CA

Printed in Great Britain

Library of Congress Catalog Card Number: 2004113315

For all general information, contact Arcadia Publishing:
Telephone 843-853-2070
Fax 843-853-0044
E-mail sales@arcadiapublishing.com
For customer service and orders:
Toll-free 1-888-313-2665

Visit us on the Internet at www.arcadiapublishing.com

On the cover: Life was much different during the early days in Gates. Even a picnic became a formal occasion when Charles Schott (back cover) and his gentlemen friends gathered on the family's Buffalo Road homestead in the early 1900s.

The Gates Historical Society strives to maintain accurate and complete archival records. Additional information about the photographs in this book would be appreciated.

The Gates Historical Society
634 Hinchey Road
Rochester, NY 14624

CONTENTS

Respectfully dedicated to the memory of Jack C. Hart (1919–2003)

Supervisor of the Town of Gates (1974–1989)

Gates Town Historian (1995–2003)

*Member of the Founding Board of Directors
of the Gates Historical Society (1998–2003)*

A HISTORY OF THE TOWN OF GATES

Western New York State evolved through several county and town name changes during its pioneer days. Eventually, the town of Northampton was reduced to the area bounded by Lake Ontario to the north, the Genesee River to the east and south, and the town of Parma to the west.

In 1808, residents petitioned the state legislature to change the name to Gates after Gen. Horatio Gates, who defeated Gen. John Burgoyne at the Battle of Saratoga in 1777.

While waiting for state approval, townspeople met on April 4, 1809, at the home of Jeremiah Olmstead to elect officers: Zaccheus Colby, supervisor; Hugh McDiarmid, town clerk; John Williams, Thomas King, and Richard Clark, assessors; Matthew Dimmick, Moses Clark, and Nathaniel Tibbles, road commissioners; Abel Rowe and Moses Clark, overseers of the poor; Richard Clark, collector; Thomas Lee, Charles Harford, Frederick Rowe, Erastus Robertson, Ashael Wilkerson, Moses Clark, and Nathaniel Jones, overseers of highways; and Abel Rowe, Augustus B. Shaw, Thomas King, and Samuel Latta, fence viewers and pound keepers.

Four years later, on June 10, 1812, the state legislature passed the bill to create the town of Gates, effective April 1, 1813.

The town was further reduced in size by the annexations of the village of Rochesterville in 1817 and the town of Greece in 1822. This series of annexations may have prevented a formal downtown or Main Street from ever having been developed in Gates.

Many early settlers were influential in shaping the town's history. John Harford is believed to have sown the first grain. Isaac Ray cleared land for a farm east of Gates Center. About a mile south, Isaac Dean established a sawmill in 1810. William Hinchey arrived at the same time to farm and build the town's first clapboard house. Eleazer Howard was the proprietor of the Howard House Tavern, at the corner of Buffalo and Howard Roads. And Ira Waite ran the first store.

Although Gates was primarily an agricultural community until the rise of the suburbs in the 1950s, several industries thrived in the early days. The Rochester German Brick and Tile Company, located on present-day Brooks Avenue, operated until the mid-1930s. John Joslyn's slaughterhouse was located off Buffalo Road where Bermar Park is today. A lime kiln on Wegman Road produced the famous Snow's White Lime.

"It took courage, a staunch faith in God, and a spirit of adventure for these early pioneers to journey with their families to the unknown West, and it is to them that we owe the existence of our town of Gates," wrote June Thomas, Gates town historian in 1963, in *From the Wilderness*, the town's sesquicentennial publication.

INTRODUCTION

On November 30, 1998, at a meeting held in the Gates Public Library, 17 residents founded the Gates Historical Society. The impetus was the possible sale of an old town landmark, the Hinchey Homestead. They hoped that an organization with a historical purpose could preserve the structure's timeless beauty in what had become a typical suburban town of subdivisions, shopping centers, and expressways.

By the fall of 1999, the society—under the leadership of Susan Swanton, founding president—received a provisional state charter and began offering monthly educational programs. Members drafted a proposed historical preservation ordinance using the model from the Preservation League of New York State. The Gates Town Board adopted the legislation in April 2000, and the first Gates Historical Preservation Commission was created three months later. Three of the original commissioners were members of the Gates Historical Society. One of their first efforts was to designate the Hinchey Homestead as a local landmark, the only site in Gates listed on the National Register of Historic Places.

At the same time, the society embarked on a major fund-raising effort to acquire the homestead. Thanks to a private mortgage from Ed McDonald and Mary Haverfield, a local doctor and his wife, the property was purchased on January 4, 2002.

Jean Kohlhoff and Laura Nolan, the second and third presidents of the society, respectively, led the organization through these first years of ownership. They began the monumental task of conducting an inventory of the incredible richness of artifacts and early records left to the society as part of the transaction. Grants were pursued year after year, as the initial funding for the society suffered the same decline that many not-for-profit organizations experienced after the terrorist attacks of September 11, 2001.

Thanks to two key contributions—a federal grant from Save America's Treasures and another from the New York State Parks, Historic Preservation, and Recreation Department—the town of Gates assumed ownership of the Hinchey Homestead in May 2004, with the Gates Historical Society serving as property manager in perpetuity.

As the society continued to grow through its Web site (www.gateshistory.org) and its programs, tours, and community archives, a group of society board members and volunteers began production of this pictorial history of the town. No other historical work specifically dedicated to the town of Gates has been published since *From the Wilderness* was printed during the town's sesquicentennial in 1963.

Many of the founding board members are deeply involved in the society's activities. More community volunteers are coming forward to help. Historical consciousness is alive and vibrant in Gates, thanks to a core group of involved and committed community residents. To understand the future, one must know the past. May this book help achieve that goal.

One
HOME LIFE

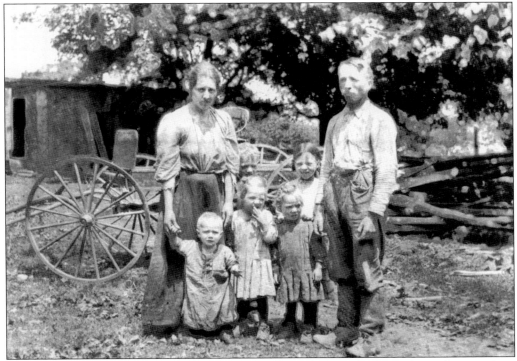

A proud and hardworking Gates family from Lyell Road suspends chores for a photograph in 1916. This family represents the groups of hardy settlers who collectively established the foundation of the town of Gates.

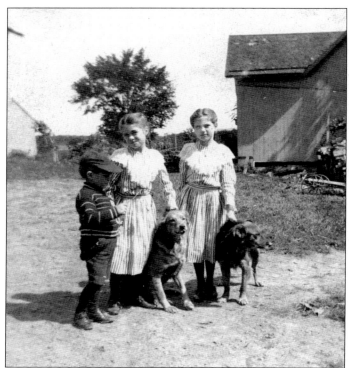

The Charles Schott farm, on Buffalo Road, was sold to the state in the early 1900s to make way for the Barge Canal. Pictured here are, from left to right, Harold (born in 1899), Henrietta (born in 1896), and Marion (born in 1894).

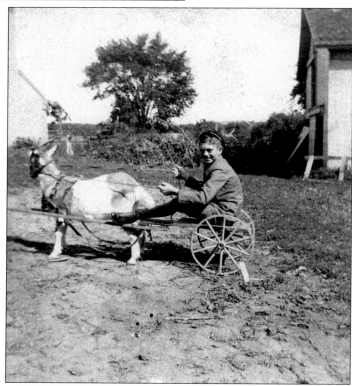

John Schott appears in an early "goat cart," a fun way to get around the farm.

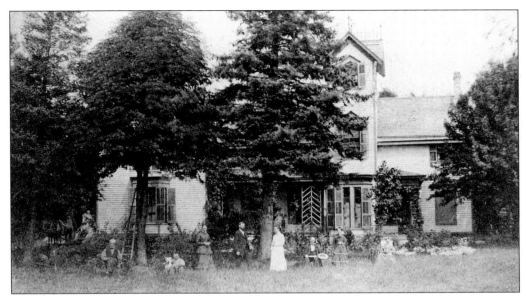

Spencer Woodworth and his wife, Amanda, traveled from Connecticut to settle in Gates *c.* 1840. By 1860, they had four children—John, Mary, Clark, and William. This photograph was taken in the mid-1860s on the front lawn of their home on Hinchey Road, east of the Hinchey Homestead. William is on the left with the family dog. Clark married Julie Booth of Chili in 1849.

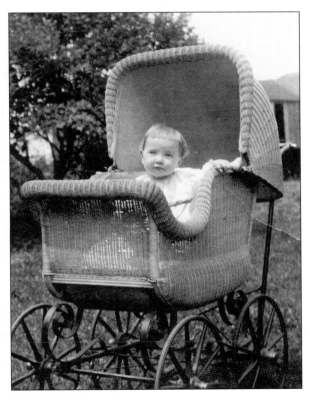

Andrew Harrington catches some rays in a popular baby buggy *c.* 1918. Andrew is the son of Charles and Mary Harrington, who both served as Gates town clerk.

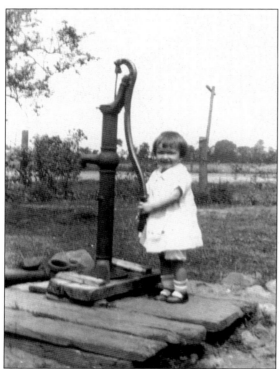

The well pump is taller than two-year-old Clotilda Hoepfl as she draws water on the family homestead in Gates c. 1930. Clotilda is the daughter of Arno and Julietta Eisenhauer Hoepfl and the granddaughter of Joseph and Julia Eisenhauer. The Eisenhauers' 59-acre farm was on Lyell Road.

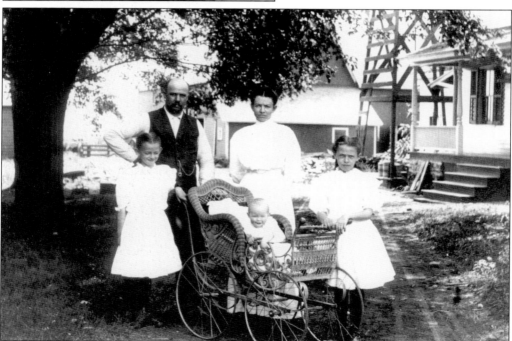

Wallace and Nellie Caudle are pictured with their children Ada and Hazel, with Pearl in the perambulator, in 1909 at their homestead, located on the south side of Buffalo Road near the present-day Gates Community Center.

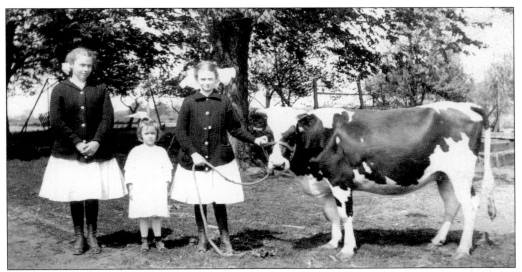

Hazel (left), Pearl (center), and Ada Caudle, dressed in their Sunday best, pose with a bull at their Buffalo Road homestead.

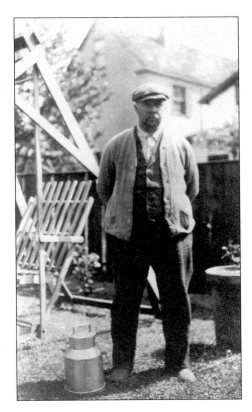

Wallace Caudle is pictured in the backyard of his Buffalo Road homestead in the early 1900s. He delivered milk to customers from a horse-drawn wagon.

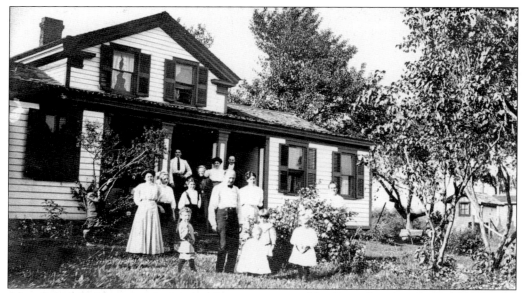

After the original homestead was razed for construction of the Barge Canal in the early 1900s, the Schott family relocated to this house off Buffalo Road, near present-day Crestwood Boulevard.

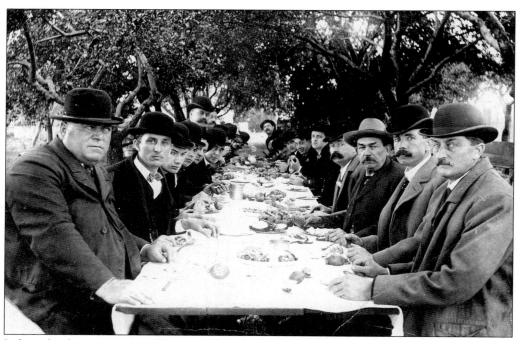

Judging by the expressions of these gentlemen, this particular picnic is serious business. Charles Schott (front, left), a wholesale butcher, joins a group of men for a meal outdoors. Note the formal attire and elegant place settings, complete with tablecloth.

A typical laundry day on the Vogel farm involves hanging the bedding and clothing on the line to dry.

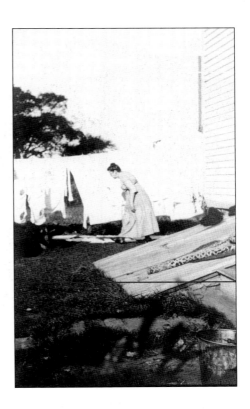

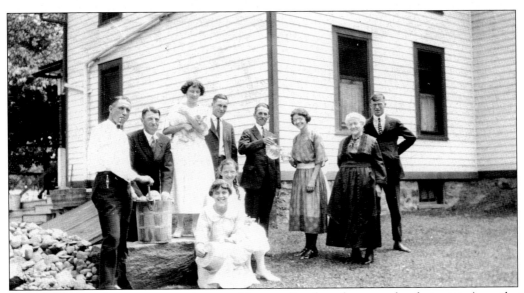

Among those making ice cream (presumably on a Sunday afternoon, by their attire) on the lawn of the Vogel farm are Herbert, Leonard, Isabelle, Lucy, and Priscilla Vogel.

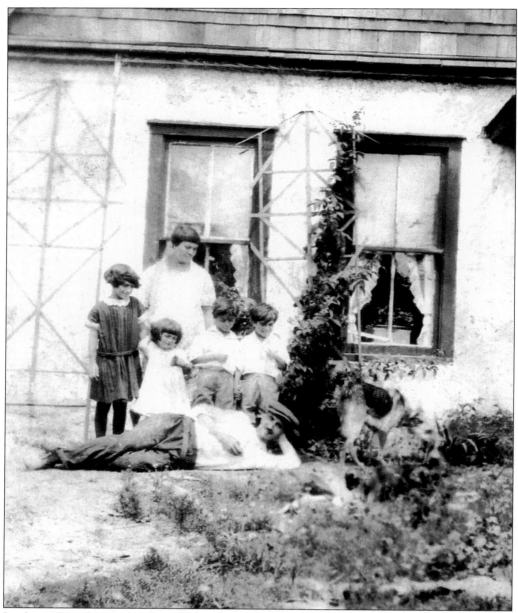

In the 1920s, the Rochester trolley rolled into Gates in the vicinity of present-day Trolley Boulevard and Long Pond Road, stopping for passengers at numbered locations. The stop designated as No. 4, Coldwater, was the home of Eustachio and Emma Rialdi and their children (Mary, Carmella, twins Angelo and Louis, and Matthew), who lived at the fork of Cole and Electric Avenues (now Downsview Drive). One day, when their parents went into Rochester for groceries, the twin brothers ventured into the fields to pick blueberries. After a few minutes, Angelo started screaming, and the kids were horrified to see a snake coiled around his legs. The family pet, a German shepherd named Gemma, broke her leash, dashed to the scene, and quickly bit off the snake's head. Although Angelo had been rescued, Gemma died the next morning, apparently from the snake's venom. This is a typical story of life in Gates decades ago.

Margaret Schott poses with her family at her son Charles's home, on the corner of Buffalo Road and Varian Lane, in 1929. The home was built with stone blasted away when the Barge Canal was excavated in 1907. Pictured here are, from left to right, the following: (first row) Homer Schott (holding Robert Schott), Charles Vowles, Charles Schott, Simon Vowles, Margaret Schott, Harold Schott, Richard Charles, and Marion Vowles (holding Margaret Vowles); (second row) Madelaine Schott, Harold Schott, Louise Schott, Margaret Bunn, William Schott, Lillian Vowles, Hulda Schott (holding Jane Charles), Janet Vowles, Fred Vowles, Henrietta Charles, John Charles Jr., John Charles Sr., and Catherine Schott; (third row) Floyd Bunn, John Schott, and Art Schott.

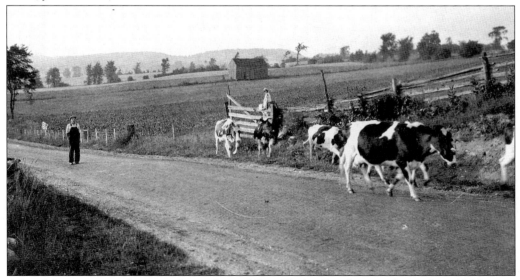

A local farmer coaxes his cows down the middle of Pixley Road, just a dirt path in 1930.

Most farms had at least one horse and plenty of room for the kids to ride. Here, Franklin Hinchey helps his children Barbara (left), William (center), and Ron saddle up in the late 1930s.

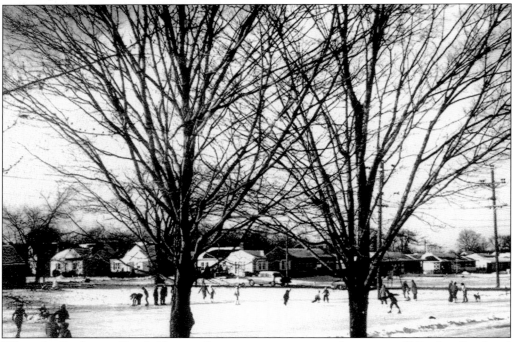

When the Rochester Gas & Electric Company property, near the corner of Hinchey Road and Jasmine Drive, flooded and froze in winter, neighbors had a ready-made skating rink. This view looks north toward Hinchey Road.

Two
TRANSPORTATION

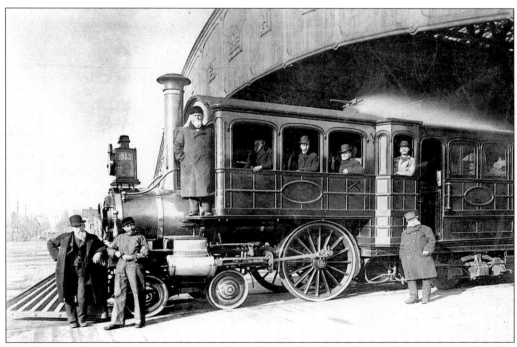

Franklin Hinchey, the son of pioneer William S. Hinchey, built the Hinchey Homestead in the 1870s. The train stopped near the Hinchey property each morning to pick up Franklin, a railroad land agent, and dropped him off again at night. He can be seen in the window, second from the right, aboard Engine 513 on the New York Central line.

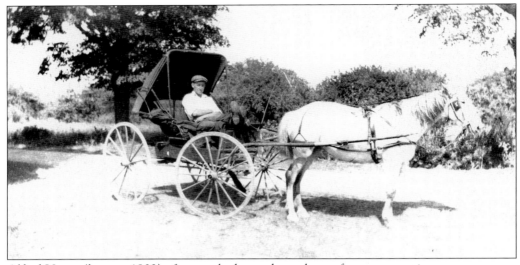

Alfred Unger (born *c*. 1900) often used a horse-drawn buggy for transportation.

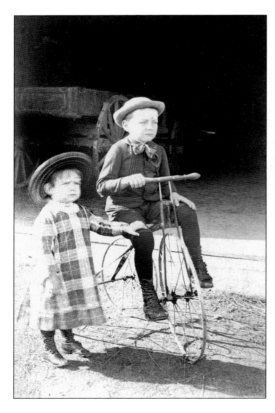

"When is it my turn?" That seems to be the question on Abby Pixley's lips as John Pixley takes a ride on a very early tricycle.

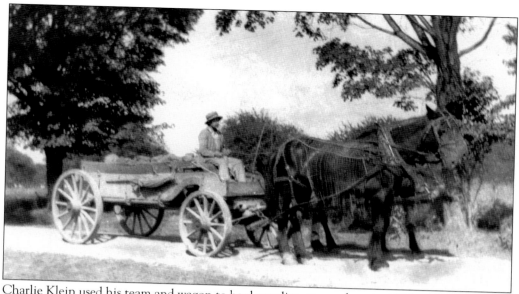

Charlie Klein used his team and wagon to haul supplies, as seen here in 1916 near Pixley Road.

William Hinchey (1874–1964) is pictured on the Hinchey Homestead with his bike. Even after the first automobiles began to overtake the horse and buggy as a primary means of transportation, bicycles continued to be a popular and efficient mode of travel.

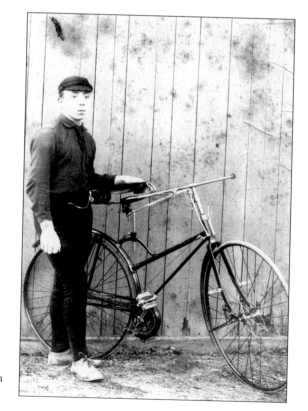

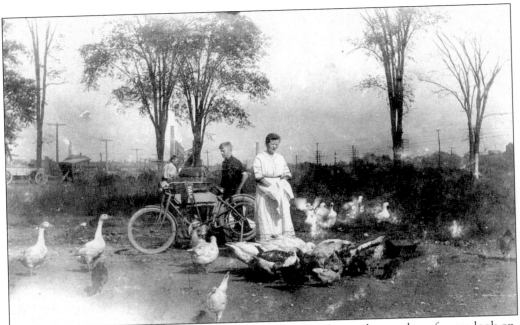

Al Schnabel, age 17, rides an early bicycle as his grandmother and a number of geese look on. The Schnabel Garage, located on Buffalo Road near Mount Read Boulevard, is still owned and operated by the family. In the early 1900s, this area was part of the town of Gates.

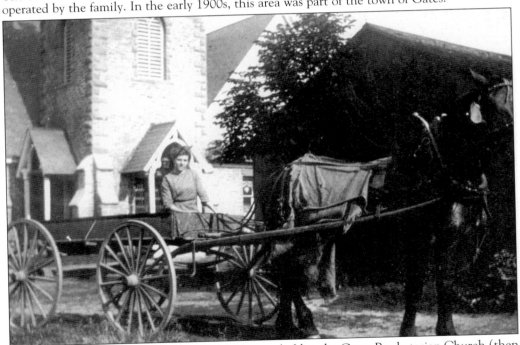

In the early 20th century, when a social event was held at the Gates Presbyterian Church (then located on Buffalo Road near Howard Road), chairs and tables were borrowed from the Gates Grange, just across the street. Here, Mary Field transports the furnishings via horse-drawn wagon on the unpaved Buffalo Road.

George Neracker travels down Howard Road in Gates with his team and wagon in 1916. He was a trustee of Gates School District No. 7, later known as the Warren Harding School, on Spencerport Road.

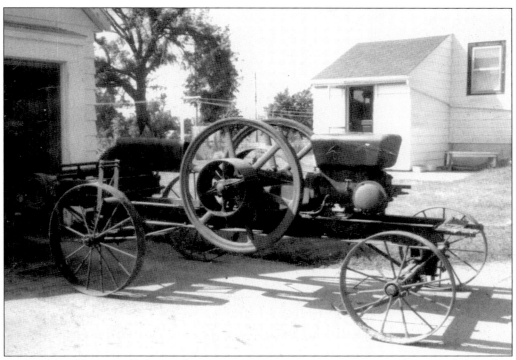

Reuben Vogel has installed a gasoline engine onto a wagon, constructing a homemade horseless carriage. Many backyard mechanics tried their hands at building automobiles when cars and trucks replaced the horse and wagon.

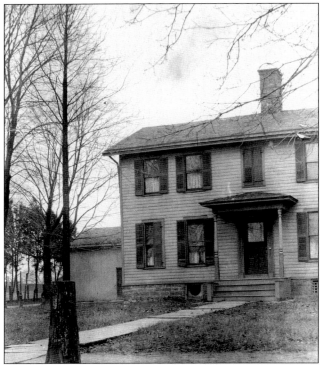

The Charles Schott home, pictured in the late 1890s, was located on Buffalo Road, just east of the current Rick's Prime Rib House in the Doud Post building. After the house was demolished to make way for the Barge Canal, the family moved about a mile west to a farm off Buffalo Road near present-day Crestwood Boulevard. Blasting for the Erie Canal (then called the Barge Canal) was under way in Gates in 1907. The view below looks north from Buffalo Road. A six-mile section of the canal passes through Gates. The photographer was less than 50 feet away when he captured this explosion, which required 450 pounds of dynamite. (Courtesy of the Albert R. Stone Negative Collection, Rochester Museum and Science Center.)

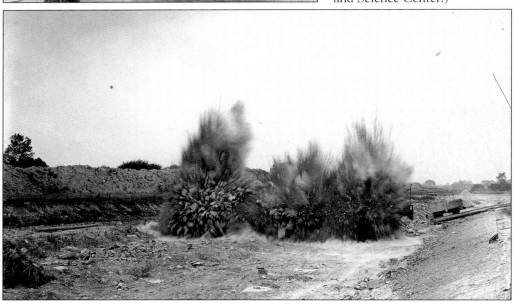

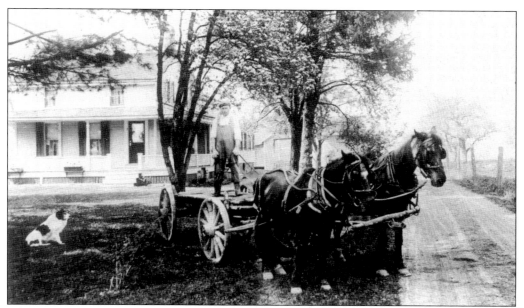

John Kenney is pictured with an open wagon and team on his father's farm, located at 12 Spencerport Road near the corner of Lyell Road. The Michael Kenney homestead was the site of the first mass ever celebrated by the congregation of St. Theodore's Church, in 1924. With 216 in attendance, the altar was moved to the porch, and the congregation assembled on the lawn. The first pastor of St. Theodore's, the Reverend John J. Baier, held services at the Kenney home until the church building was dedicated in October 1925.

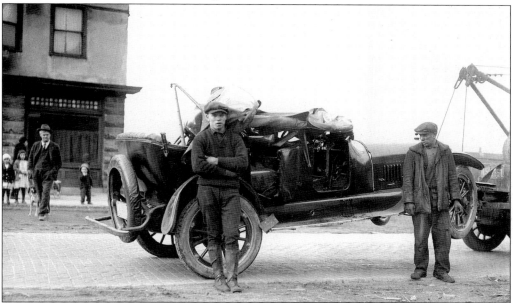

News reports of the day indicated that seven people were hurt when this early automobile was involved in an accident on a section of the newly paved Buffalo Road. The car is ready to be towed in this 1924 photograph from the *Rochester Herald*. (Courtesy of the Albert R. Stone Negative Collection, Rochester Museum and Science Center.)

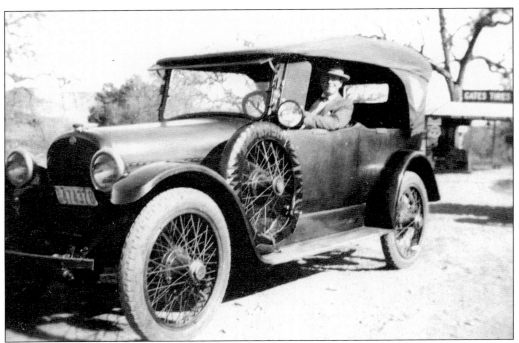

Charlie Schott drove this Nash from Los Angeles to the town of Gates in eight days (and with no air-conditioning or Holiday Inns available).

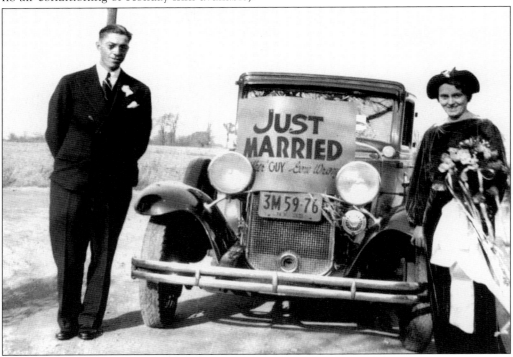

Couples have been proclaiming their weddings on cars for years. Alphonse B. DeYeager and Ottilia A. Eisenhauer did the same on their wedding day in 1935.

Glanville and Frederick Vowles pose with one of the first trucks in Gates in this photograph taken on the Schott Farm off Buffalo Road.

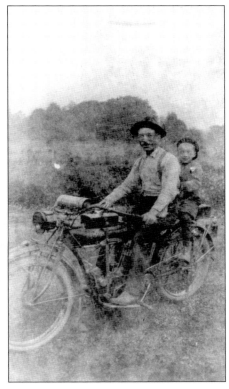

An unidentified man and boy ride on an early motorcycle in the town of Gates in 1916.

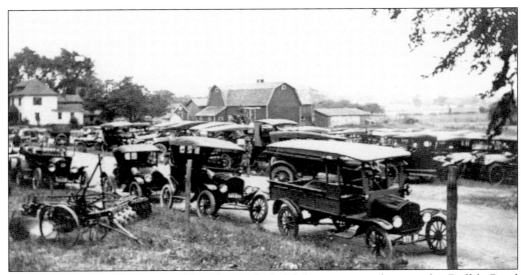

Cruise nights are nothing new, although it is doubtful that everyone drove to this Buffalo Road farm just to show off their newfangled automobiles. A celebration is the most likely reason for this gathering in the 1920s.

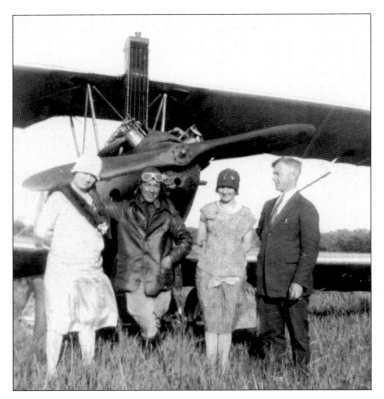

The field in back of Ackerman's Hotel and Restaurant, at the corner of Howard and Spencerport Roads, was used as a landing strip for early aircraft. Here, citizens inspect a plane that has landed there. Today, the corner where Ackerman's stood is occupied by a gas station, and the field where the airplanes landed is the Chase-Pitkin Home Center.

Three
BUSINESSES

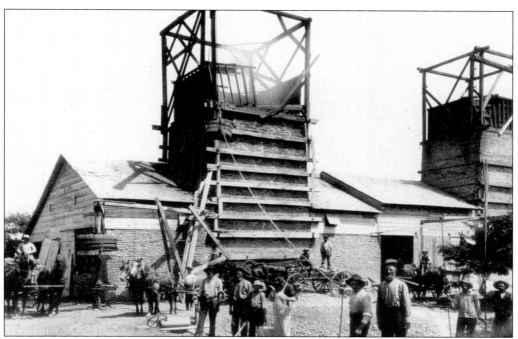

A lime kiln operating on the west side of Wegman Road *c.* 1900 produced Snow's White Lime, a product of some renown in its day. The kiln was demolished years ago, and Interstate 490 now passes through the site.

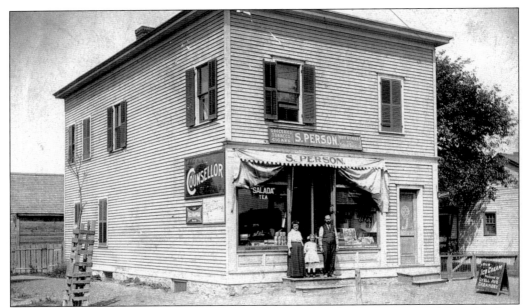

Mary Ann Person, her husband, Gates justice of the peace Sebastian Person, and their daughter Hyacinth are pictured outside Judge Person's grocery store *c.* 1908. The store was located at the corner of Lyell Avenue and Field Road (now Mount Read Boulevard), then part of Gates. Judge Person is the grandfather of two former Gates town judges, Patrick S. Egan and David D. Egan. David is currently a New York State Supreme Court judge.

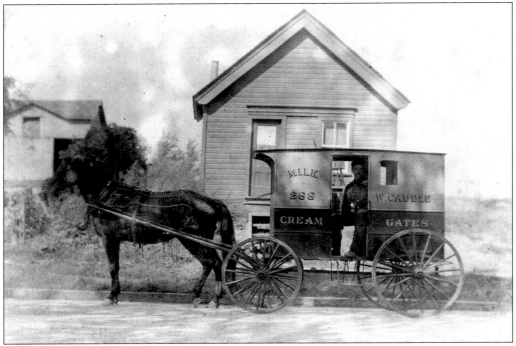

Wallace Caudle, who lived with his family on the south side of Buffalo Road near the present-day Gates Community Center, delivered milk to the townsfolk from his horse-drawn wagon.

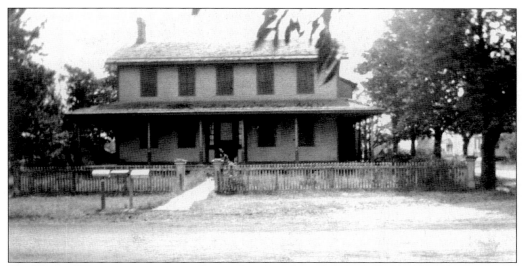

The Howard House was a stagecoach stop, hotel, and restaurant in the town's early days. Built by Eleazer Howard c. 1825, it stood until 1956 on the southeast corner of Buffalo and Howard Roads where the Dave Green Automotive Garage is today. The Gates Presbyterian Church was organized in the Howard House in 1828. Howard then donated land for a new church building and cemetery just a few hundred yards east on Buffalo Road.

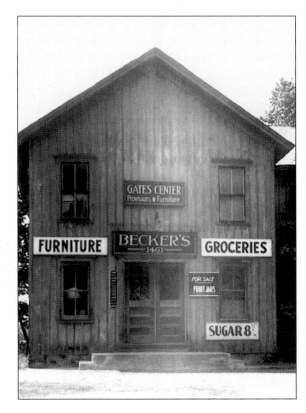

Becker's, a market on the south side of Buffalo Road just east of the intersection with Howard Road, was originally located on Front Street in Rochester. Constructed in the 1880s, the building was owned by the Templar's Union and the Gates Grange until the Becker family purchased the site.

31

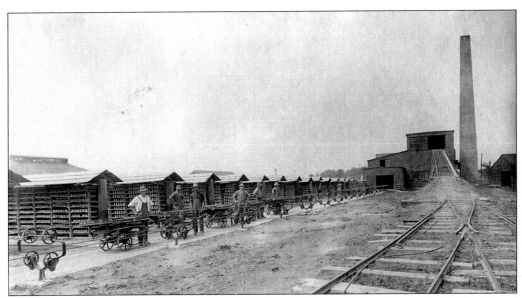

The view above shows the brickyard and the railroad. The one below shows the brickyard and the kilns.

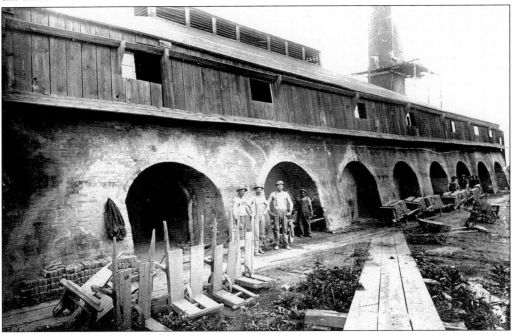

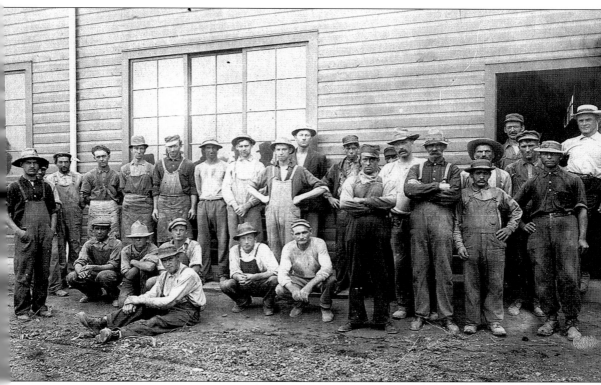

An extensive deposit of red clay made it possible for the Rochester German Brick and Tile Company (left and above) to produce more than 40,000 bricks a day at the brickyard on Brooks Avenue, where the Greater Rochester International Airport is now located. Because of the fires in the kiln, the brickyard was a favorite stopover for hoboes seeking a warm place to sleep. Steam shovels dug and loaded the clay onto cars that were taken by team or trucks to the mixing plant and then to the kiln, where the clay was molded and dried. At its peak, the company employed about 60 workers. Operations ceased in 1935.

Joseph Harris (1828–1892) purchased a 141-acre farm at the corner of present-day Buffalo and Manitou Roads in 1863 for $14,250, named it Moreton Farm after his boyhood home in England, and established the Joseph Harris Seed Company in 1879. He was also the owner and editor of the *Genesee Farmer*, associate editor of the *Country Gentleman*, and president of the Genesee Valley Horticultural and Monroe County Agricultural Societies.

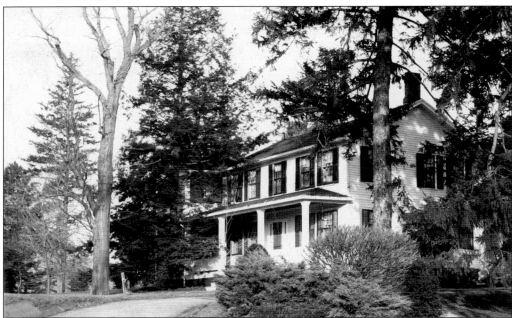

The Joseph Harris homestead, built in the 1830s, was part of the original farm purchased by Mr. Harris during the Civil War. It was located on the north side of Buffalo Road, just east of the corner of Buffalo and Manitou Roads. The homestead served as the first headquarters for the Harris Seed Company. Recently, the property was sold and the homestead demolished.

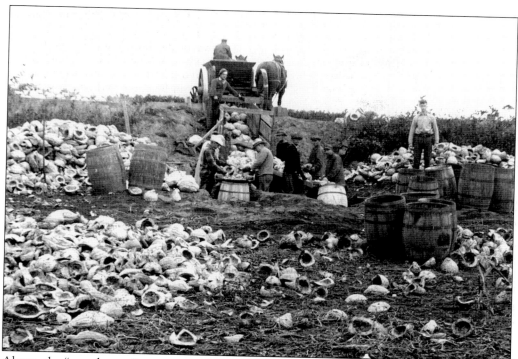

Above, the "squash gang" removes seeds from jumbo Hubbard squash at the Harris Seeds farm in the 1930s. Plenty of hands were required because the seed mechanism was a cumbersome horse-drawn apparatus. Carl Warren (second from the left) served as general manager of Harris Seeds. Below, a Moreton Farm driver prepares for a delivery of Irondequoit melons in the late 1920s.

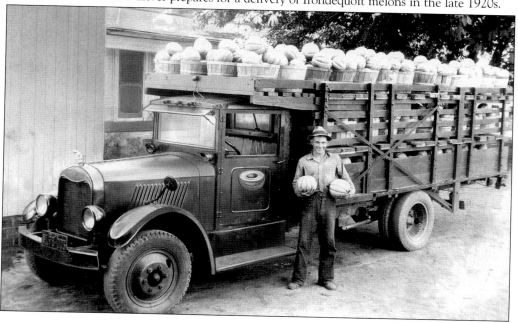

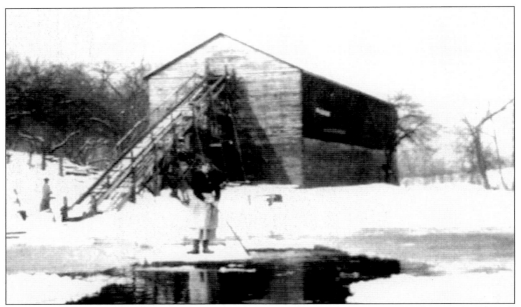

Early residents of Gates harvested ice during cold weather and stored it in icehouses lined with sawdust. This icehouse was at the end of present-day Fairholm Road, off Beahan Road. Neighbors blocked Little Black Creek to create water pools that would freeze during the winter months.

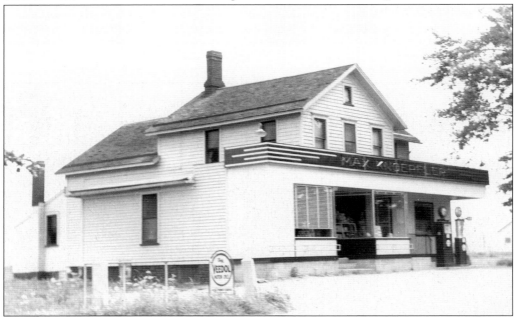

Max Knoepfler operated a grocery store and market on Coldwater Road in the early 1900s. In 1947, the Knoepflers sold it to Leo Entress, who sent the following notice to customers: "The business establishment now operated by Mrs. Max Knoepfler, 560 Coldwater Road, will become the property of Leo Entress. The good will of all the present and past patrons will be very deeply appreciated. All efforts will be made to give the customers an efficient and modern store in which they can trade with convenience and celerity. Respectfully yours, Leo Entress."

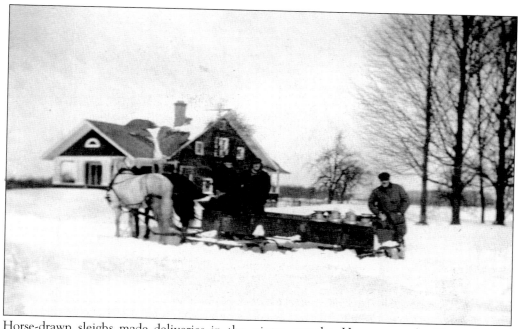

Horse-drawn sleighs made deliveries in the winter months. Here, cans of milk are hauled through the snow along Buffalo Road near Howard Road. The home of Chester and Sadie Field appears in the background.

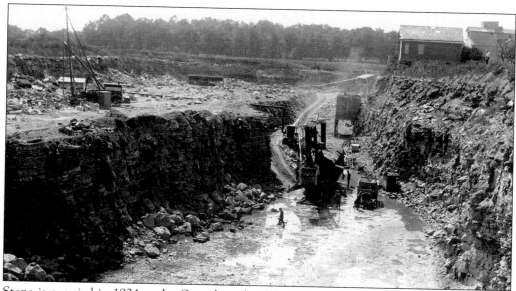

Stone is quarried in 1924 at the Gates branch of the Dolomite Products Company, located off Buffalo and Howard Roads. In the 1940s and 1950s, dynamite was stored in an earthen vault with a reinforced door in the wooded area off Howard Road on the south side of the railroad tracks.

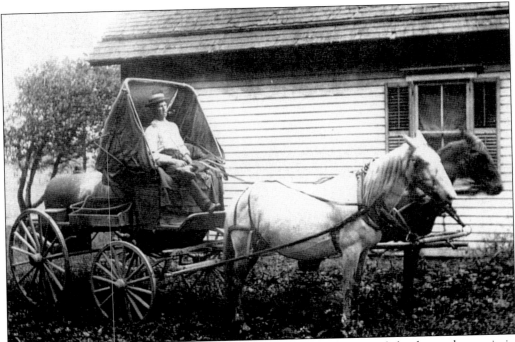

Merris Nichols, of the hamlet of Coldwater, delivers a tank of oil with his horse-drawn rig in the early 1900s.

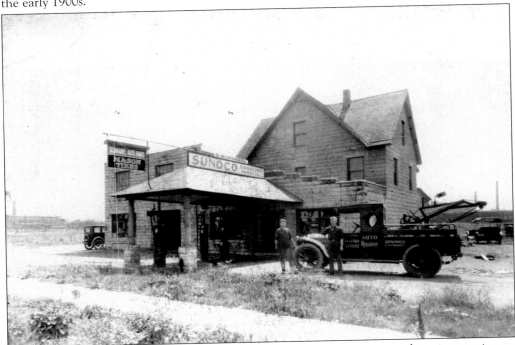

The Schnabel family operated a garage, gas station, auto-parts store, and towing service on Buffalo Road near Mount Read Boulevard, part of the town of Gates in the early 1900s. This photograph was taken c. 1920. The business remains in operation today.

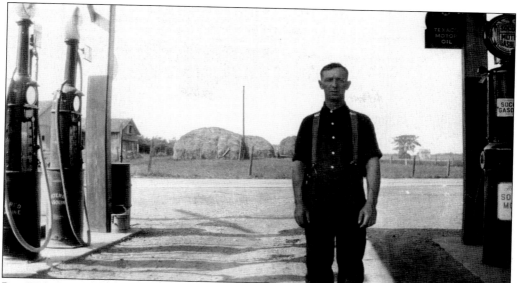

Roy Wilcox operated the first gas station in south Gates, located at the corner of Chili Avenue and Beahan Road.

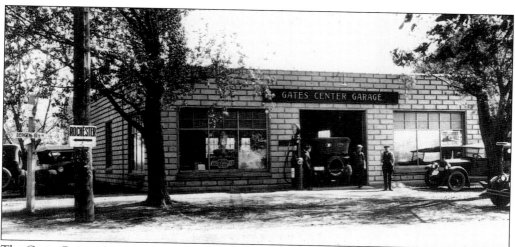

The Gates Center Garage, pictured c. 1925, was located on the southwest corner of Buffalo and Howard Roads, only a car width or two off the dirt highway. The garage and the grocery store in the house next door were owned by Walter Happ and leased by Charles W. Schrader. He had two partners, his brother Frank Schrader and Sherman Henry. The repair business and gas station operated from c. 1924 until Buffalo Road was closed for paving in the late 1920s. The building later became Nichols Garage. Today, a self-service Hess gas station occupies the site.

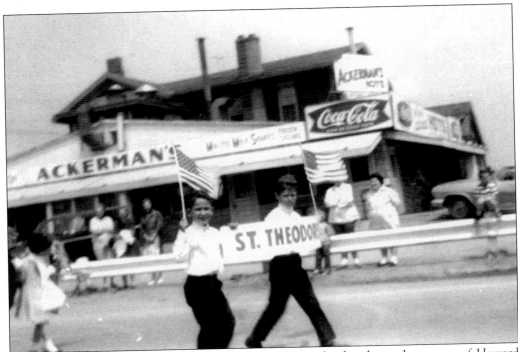

Ackerman's Hotel and Restaurant were longtime Gates landmarks at the corner of Howard Road and Lyell Avenue. Built in 1844 by Robert Currier as a stagecoach stop on the route to the West, Ackerman's later became best known for its hot dog stand. The buildings were torn down in the late 1900s to make way for Wegmans Food Market, the Chase-Pitkin Home Center, and a gas station. Above, a parade passes by as customers at Ackerman's look on. Below, employees prepare hot dogs for the post-parade crowd.

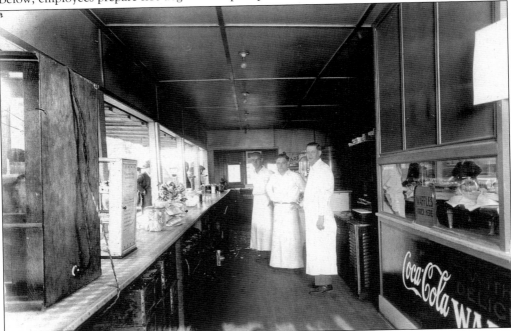

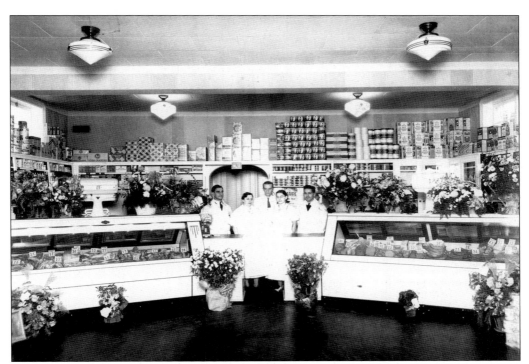

Stadler's Meat Market was located on the west side of Howard Road, near the intersection of Lyell and Spencerport Roads. The building still stands today. Above, at the grand opening in 1937, owners Frank and Josephine Stadler pose with three unidentified employees. Note the telephone number on the Stadler's delivery truck seen in the photograph to the right.

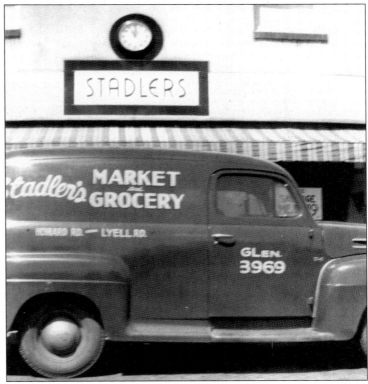

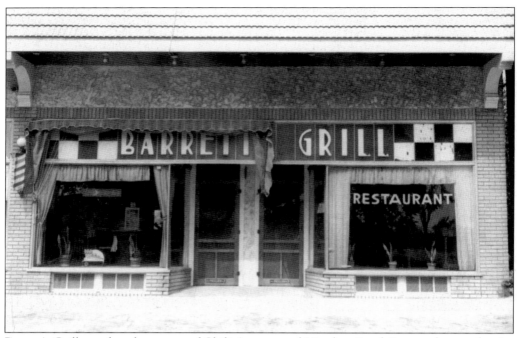

Barrett's Grill stood at the corner of Chili Avenue and Hinchey Road. Later, a bar on the site was known as Tim's Tavern. The building no longer remains.

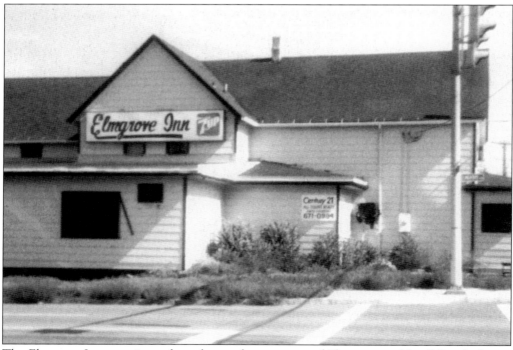

The Elmgrove Inn was situated on the northeast corner of Elmgrove and Lyell Roads. It was demolished in the 1990s.

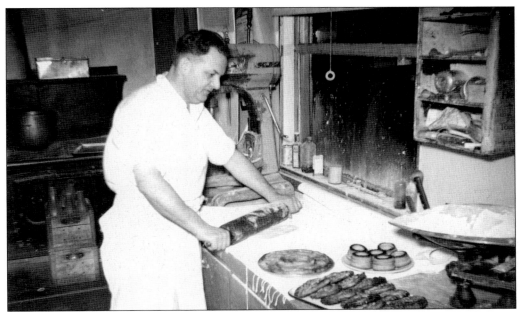

In the 1940s, the Thome family operated the Empire State Diner on the north side of Buffalo Road, across from the present-day Dolomite quarry. In these 1949 photographs, Frank Thome (above) makes his renowned homemade pies and baked goods, and Helen Thome and Gloria Thome Klink (below) work at the counter. In the 1960s, Becker's Big Boy Restaurant occupied this site.

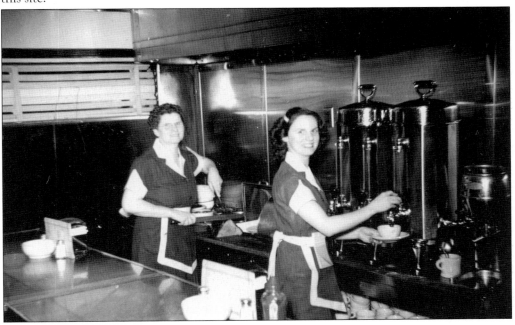

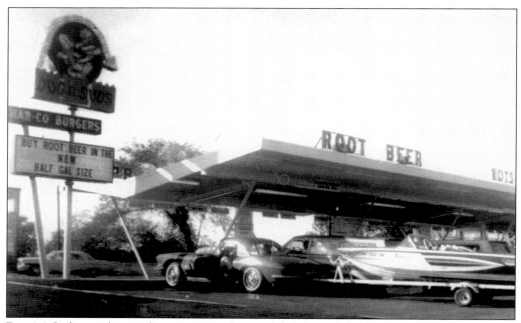

Dog 'n' Suds, on the northeast corner of Long Pond and Spencerport Roads, advertised the "world's creamiest root beer" and "Char-co" burgers in 1963. Owned by the Bosdyk family, the drive-in was later converted to a full-service family restaurant, which closed in 2004.

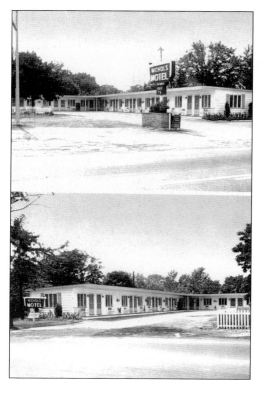

Nichols Motel, seen here *c.* 1950, was located on the south side of Buffalo Road near the intersection with Howard Road and was built in an L shape. After the motel closed, the building was moved to a site in Canandaigua, where it is still a functioning motel.

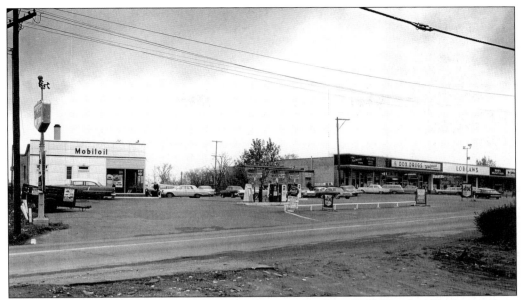

Chili Avenue was a two-lane road when this photograph of the Chili-Hinchey Plaza was taken, c. 1962. The plaza is currently being renovated, though the gas station is still in operation. Harold Quartley of Chili operated the station in the 1960s. He later ran a service station on Spencerport Road before becoming the head school bus mechanic of the Gates Chili Central School District.

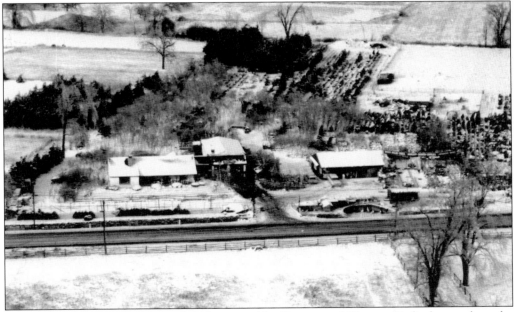

Kodisch's Garden Center, owned and operated by Francis and Eleanor Kodisch, stood on the north side of Buffalo Road, just east of the corner of Pixley Road, from 1958 to 1974. Following the death of Francis, Robert and Patricia Martell purchased the enterprise and today operate the Garden Factory. The Martells have expanded the Kodisches' original 5.2-acre site to about 30 acres.

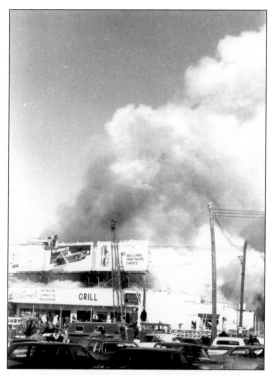

Through the years, fires have taken their toll on Gates businesses. To the left, fire damages the stores on the corner of Chili Avenue and Hinchey Road in December 1966. Below, flames destroy the Wishing Well Restaurant on Chili Avenue on January 13, 1960. Luckily, a family of four living on the second floor escaped the flames. All Gates-Chili fire companies responded to both alarms.

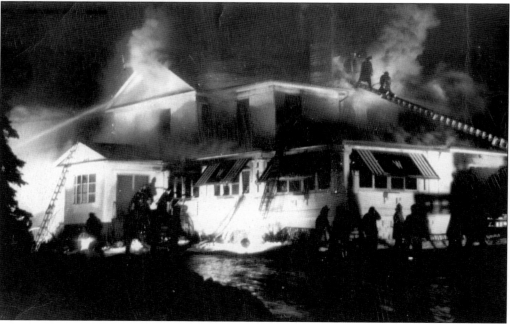

Four

THE HINCHEY
HOMESTEAD

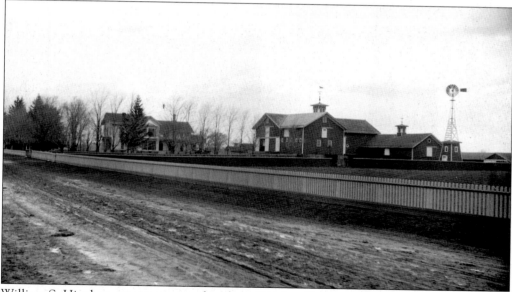

William S. Hinchey, a town pioneer for whom Hinchey Road is named, settled south of Gates Center *c.* 1810 on a farm near the current intersection of Hinchey and Howard Roads. His son Franklin built the family homestead in the 1870s. It stands today as the only structure in the town of Gates listed on the National Register of Historic Places. Pictured *c.* 1900, when Hinchey Road was a dirt path leading from Chili Road into central Gates, the Hinchey farm comprised more than 300 acres. The homestead remained in the Hinchey family until the Gates Historical Society acquired the site in 2002. The society transferred ownership to the town of Gates in 2004.

Seen here are Ellen Lytle Hinchey (1832–1920) and her husband, Franklin Hinchey (1828–1912). They, along with their son William, were the first occupants of the Hinchey Homestead, built in the Italianate style by Mr. Hinchey.

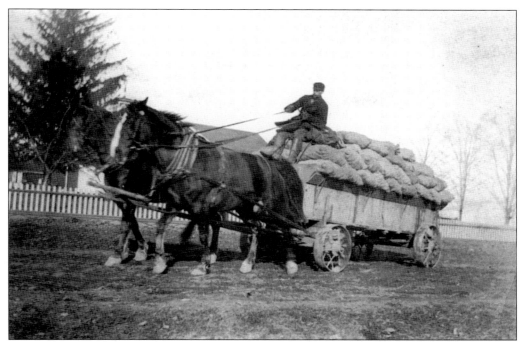

The Hinchey farm was a self-contained enterprise providing nearly everything a pioneer family needed. Here, Fred Hartrick brings in the apple harvest on a horse-drawn wagon.

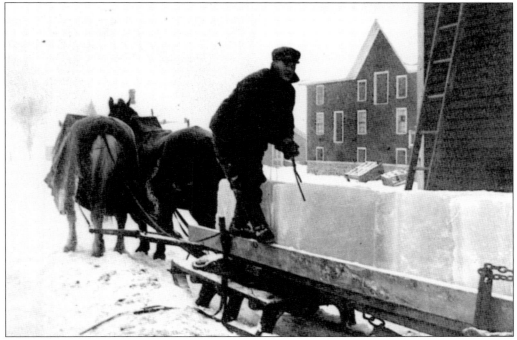

Bill Bishop hauls blocks of ice on the Hinchey Homestead *c.* 1895. Ice was cut from nearby ponds during winter months and stored in sheds lined with sawdust. Some years the ice lasted well into August.

Ellen Lytle Hinchey was born in Chili in 1832. She married Franklin Hinchey on February 2, 1871.

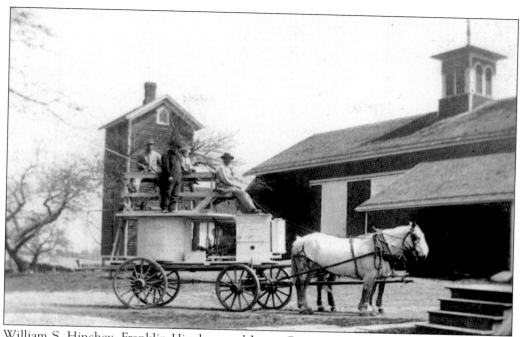

William S. Hinchey, Franklin Hinchey, and James Cummins prepare for a day's work with a horse-drawn wagon outside one of the many barns on the farm. Only one barn remains today.

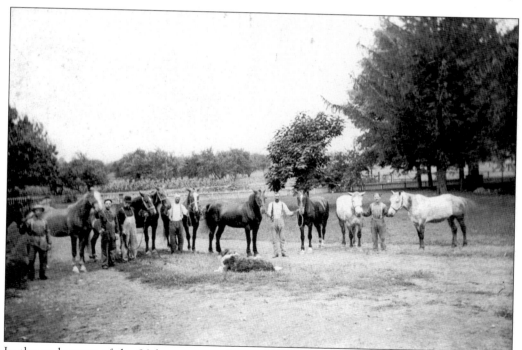

In the early years of the 20th century, a farm ran on real horsepower. Among the farm hands lining up horses near a pasture are William Hinchey, John Brown, Abe Derocher, James Cummins, and John Switzer.

William S. Hinchey (1874–1964) and Ellen Terrill Hinchey (1872–1940) are pictured shortly after their 1896 marriage. Among the family mementos donated to the Gates Historical Society is a printed invitation from William's parents inviting friends to a reception at the homestead on October 16, 1896, to meet "our son and his wife."

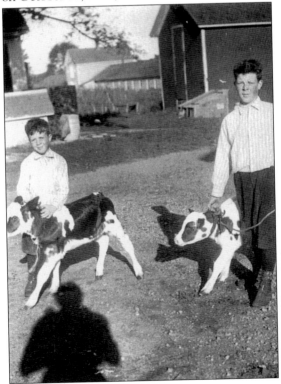

Harmon and Franklin Hinchey, sons of William S. and Ellen Hinchey, are seen in the barnyard with registered calves in 1916. For many years, the Hincheys raised Holstein cattle that grazed on the family's farmland, a portion of which is now the Brook-Lea Country Club.

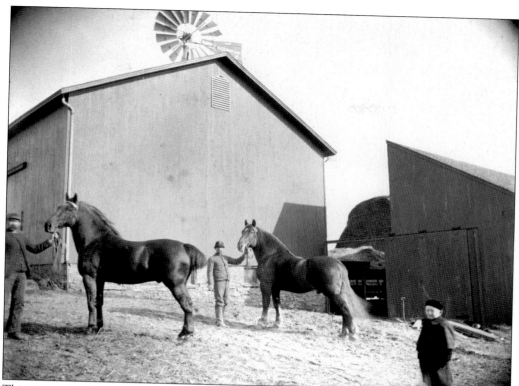

This is a typical scene on the farm in the early 1900s, with the barn and windmill in the background. Today, all of the Hinchey Homestead outbuildings are gone except for one barn located behind the house.

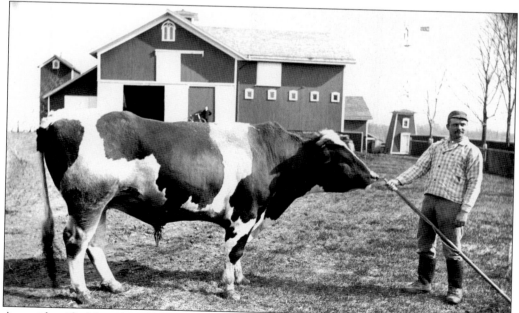

An unidentified farm hand leads a Holstein bull outside the main barn on Hinchey Road.

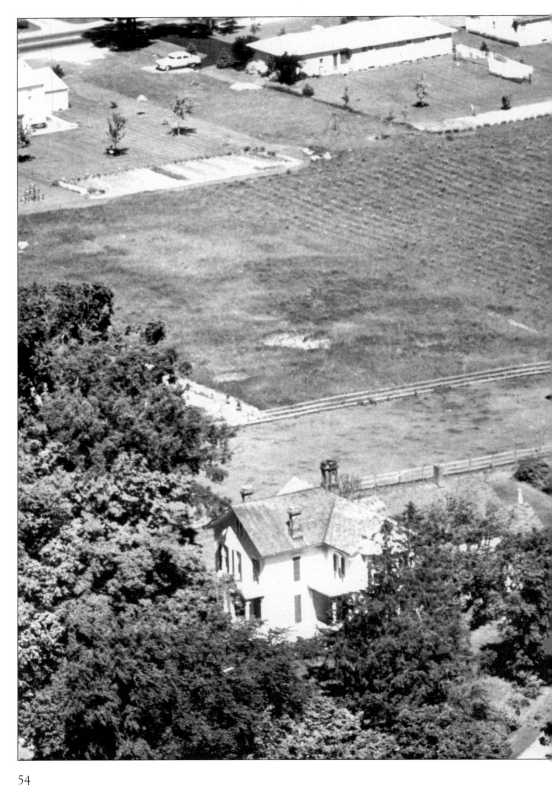

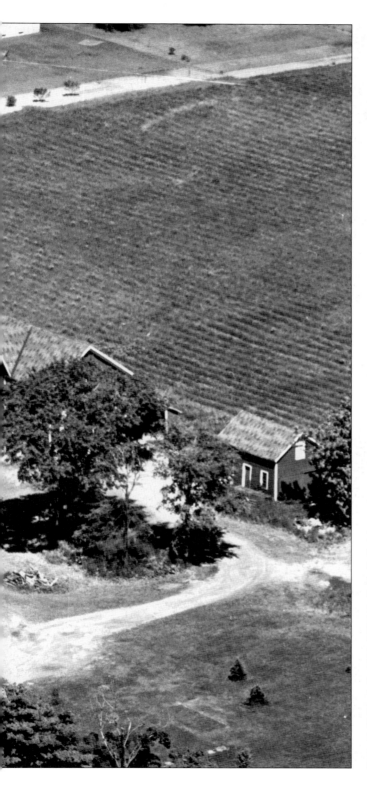

By the mid-1950s, much of the Hinchey farm had been sold to housing developers, as the town of Gates began a transition from rural farmland to suburbia. Present-day Howard Road is in the upper left portion of this photograph, and several homes and backyards on the east side of Howard Road are visible. At the upper right are plowed fields, the last acreage farmed by the family. Today, these fields are fully overgrown with large timber and evergreens.

55

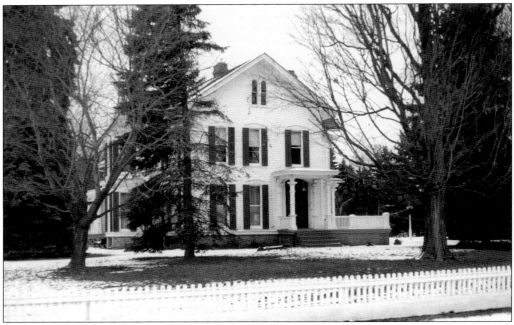

The homestead at 634 Hinchey Road remained in the Hinchey family until the Gates Historical Society acquired it in 2002. The historical society was chartered by the state of New York on September 17, 1999. The charter was amended on June 18, 2002, to enable the society to "own, open and maintain the Hinchey homestead as an historic site." In 2004, the title to the homestead was transferred to the town of Gates.

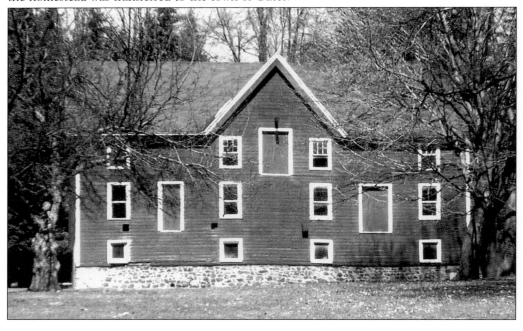

Five

FARMING

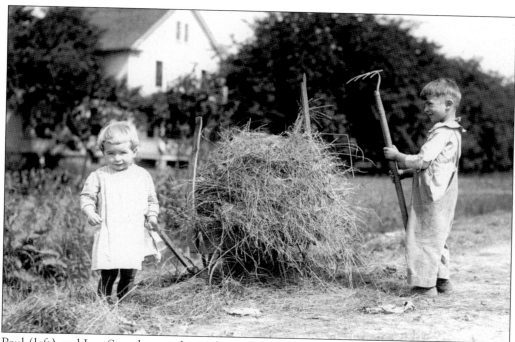

Paul (left) and Leo Statt harvest hay, "doing their bit for the war effort," in this July 17, 1918, photograph from the *Rochester Herald*. Their family's homestead was located on Statt Road. (Courtesy of the Albert R. Stone Negative Collection, Rochester Museum and Science Center.)

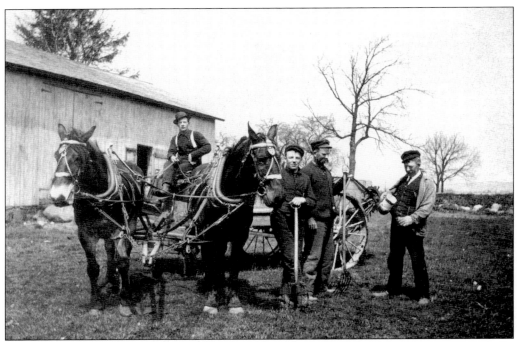

In the early 1900s, the Harrington farm was located on Buffalo Road west of the Grange hall.

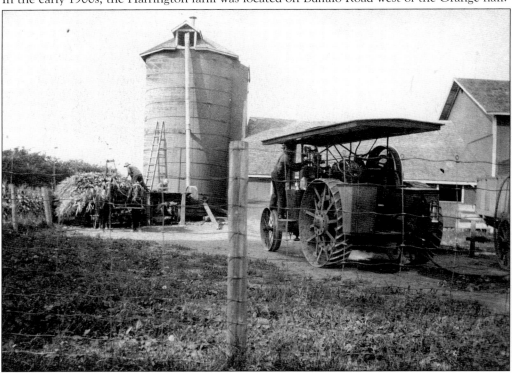

Farm hands unload a wagon filled with hay near the silo on the Vogel farm. Note that a steam tractor has pulled the wagon.

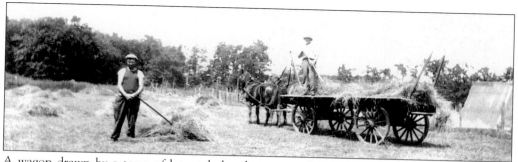

A wagon drawn by a team of horses helps the crew to bring in hay on the Metcalf farm on Buffalo Road.

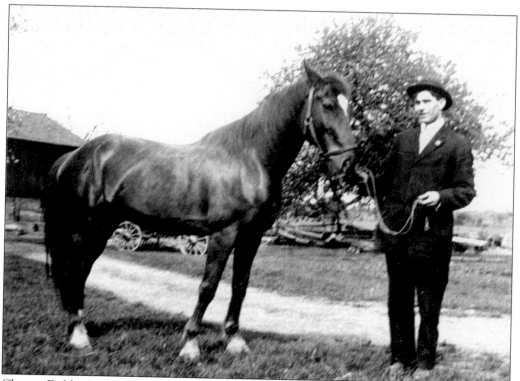

Chester Field, seen here, is the son of Reuben Field, who served as Gates supervisor in the mid-to late 1800s, and the grandson of the first Chester Field, who settled in Gates in 1820. Today, the Field homestead still stands on the north side of Buffalo Road, across from Becker's Furniture Store. Many former students of the Thomas Edison School remember Mr. Field as the school custodian in the 1940s and 1950s.

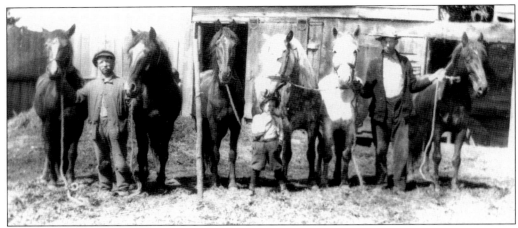

Two unidentified men and a boy tend to six horses on the Al Sauer farm on Lyell Road in 1916.

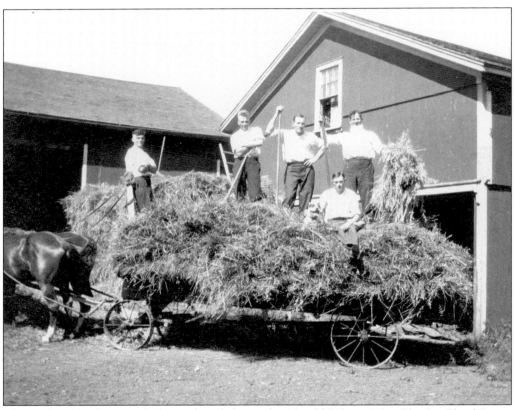

This mid-1920s photograph shows, from left to right, Harold Schott, John Charles, Floyd Bunn, Fred Vowles (seated), and an unidentified farm hand bringing in a load of hay on the Schott farm off Buffalo Road.

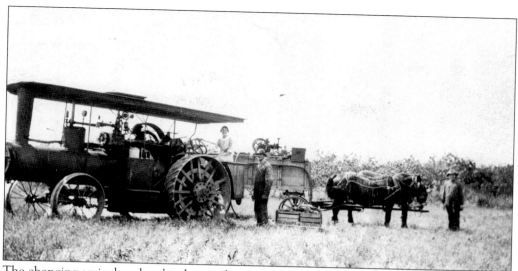

The changing agricultural technology is demonstrated in this photograph of the Vogel farm in the early 20th century. Horses and a steam tractor appear together in the field.

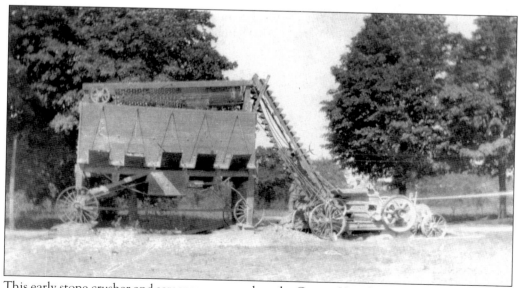

This early stone crusher and screener were used on the George Hess farm in 1916. The farm was on Spencerport Road just west of the present Gates Bowl.

Andrew Harrington (right) and a hired farm hand are pictured on the Harrington homestead on Buffalo Road.

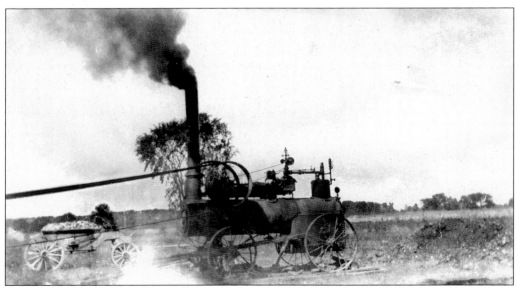

On the George Hess farm, a steam engine owned by the town of Gates is in operation in 1916.

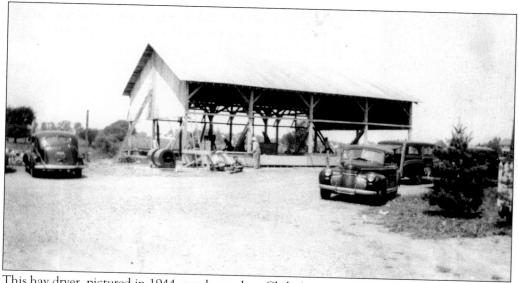

This hay dryer, pictured in 1944, was located on Chili Avenue near Howard Road on the farm of Wesley Moffett. Later, the Idylbrook dairy store was located on the site. Wesley Moffett opened Idylbrook, which eventually featured 10¢ hamburgers.

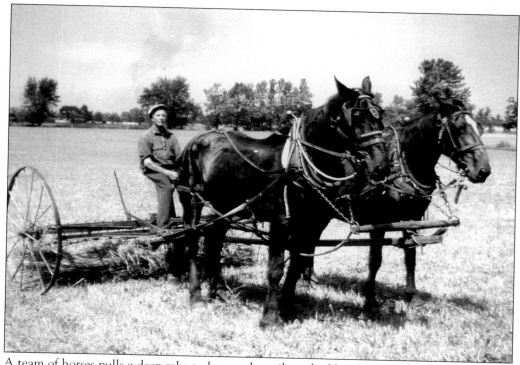

A team of horses pulls a deep rake to loosen the soil on the Vogel farm in 1943.

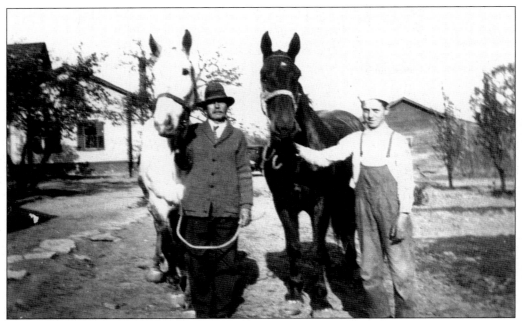

In the early 1930s, Joseph Eisenhauer and his son Joseph Nicholas Eisenhauer (above), lead two horses on the family farm at 3245 Lyell Road. The Eisenhauers purchased 59 acres from the Fullagers, who had originally cleared the land for farming in 1872. The farmhouse is still standing. Bernadette (below), the daughter of Joseph and Julia Eisenhauer, seems a bit overdressed for a day's work on a horse-drawn field rake.

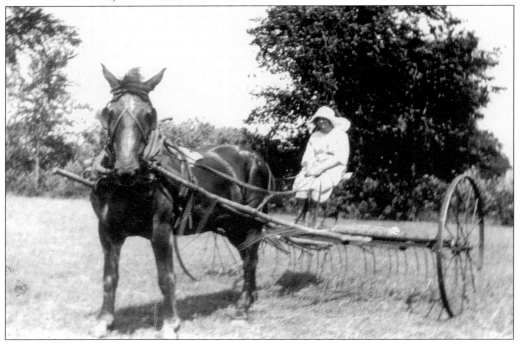

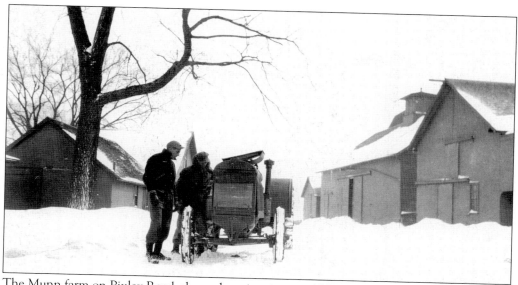

The Munn farm on Pixley Road, shown here in winter *c.* 1930, extended from Buffalo Road to the New York Central Railroad tracks.

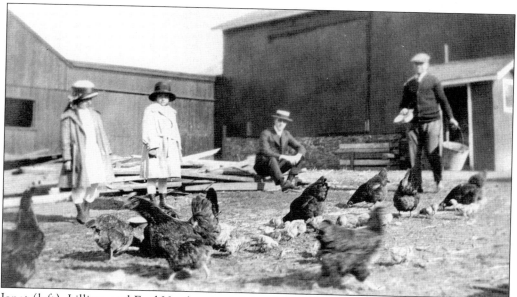

Janet (left), Lillian, and Fred Vowles watch John Schott feed the chickens at the Schott farm on Buffalo Road *c.* 1925.

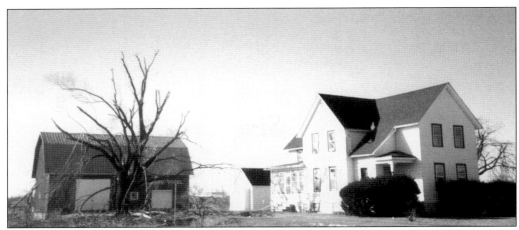

A familiar sight to many town residents is the Leonard Vogel homestead on Buffalo Road. Located opposite Sky Acres, it was razed in the 1990s to allow for several construction projects, including the DePaul Community Services building.

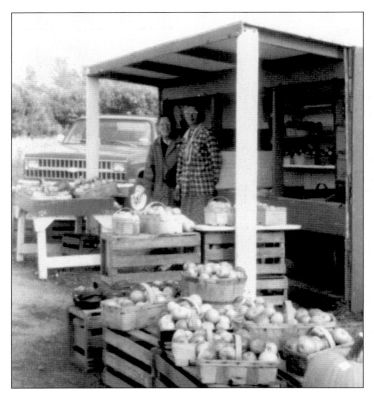

The Vogel farm produce stand on Buffalo Road is remembered by generations of regular customers. Pictured here in the 1980s are Elizabeth and Priscilla Vogel.

Six
GOVERNMENT SERVICES

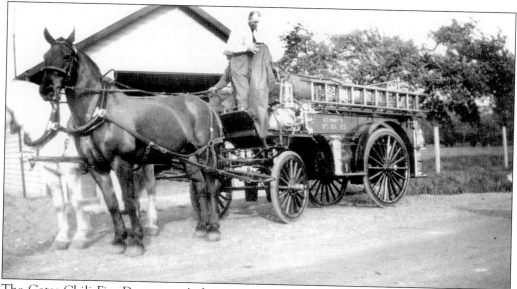

The Gates-Chili Fire Department's first apparatus was the horse-drawn Hose Truck No. 21, acquired from the Rochester Fire Department for use on St. Mary's Farm on Fisher Road. Volunteers used it from the spring of 1927 until January 1928, when the department purchased a GMC truck body for $2,400 and transferred the chemical tanks to the motorized unit. The truck was housed in a shed attached to the side of Seth Ford's grocery store at 2349 Chili Road, near the corner of Fisher Road.

Charles J. Diringer, superintendent of St. Mary's Farm, contributed the farm's horse-drawn chemical hose truck and became the first chief of the Gates-Chili Fire Department. He served from 1927 to 1930.

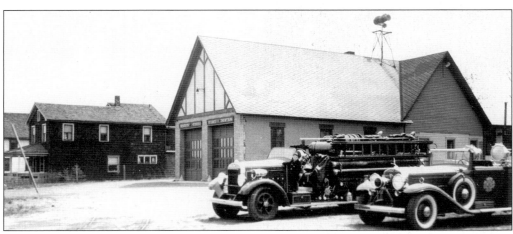

The fire department's first permanent station, at 2355 Chili Avenue, was originally the Common School District No. 1 schoolhouse, purchased in 1931 for $2,000. Volunteers renovated the station with donated materials and labor. The vehicles pictured are a 1933 Mack 500-gallon truck and a 1931 Cadillac coupe squad car.

Florence L. Ambeau, at the radio controls in 1961, was known throughout Monroe County as the voice of the Gates-Chili Fire Department. She and her husband moved from their home on Mareeta Road into the original fire station on Chili Avenue in 1954. With an annual salary of about $2,000, she became the fire department's first full-time dispatcher and was on call 24 hours a day, seven days a week, to answer the emergency telephone, activate the siren, and alert volunteers via radio. She retired in 1970 after 16 years of service and was honored at a testimonial dinner attended by local and county dignitaries, including Monroe County sheriff Albert W. Skinner.

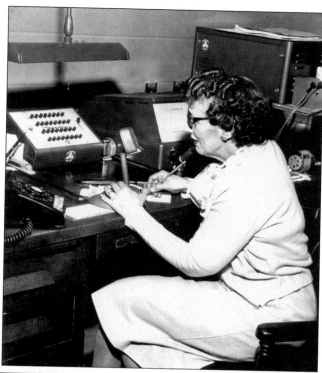

Gates-Chili Fire Department secretary George Weitzel and an unidentified firefighter display a nozzle and hose from one of the Mack trucks purchased in 1933.

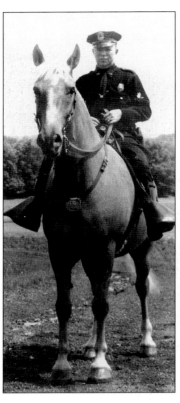

Samuel J. Raab, a Monroe County special deputy sheriff, lived on Calhoun Avenue in Gates.

The Schott homestead, photographed in the late 1800s, was one of the first jails in Gates, as revealed by the bars on its windows. Part-time town constables made arrests and held prisoners until sheriff's deputies arrived to transport them to the Monroe County jail. The farm was located near present-day Crestwood Boulevard on land that now includes LeManz, Landau, and Avanti Drives.

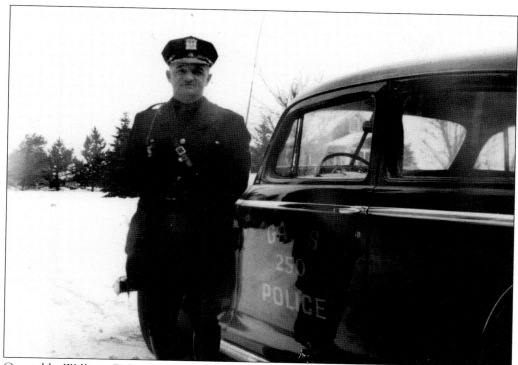

Constable William DeRuyscher stands alongside police car No. 250 in the late 1940s. His family homestead was located at the corner of Long Pond and Spencerport Roads.

Monroe County sheriff's deputies and part-time town constables were the first law enforcement officers in Gates. When a town police department was established in 1960, part-time officer William Stauber (right) became Gates's first full-time chief of police. He was joined by officers Kent Lechner in 1961, Lewis Bryant in 1962, and Norbert L. Gerow and Gerald R. Thurley in 1963. This *Gates-Chili News* photograph of Chief Stauber was taken less than a month before his sudden and untimely death on April 17, 1973, at the age of 39.

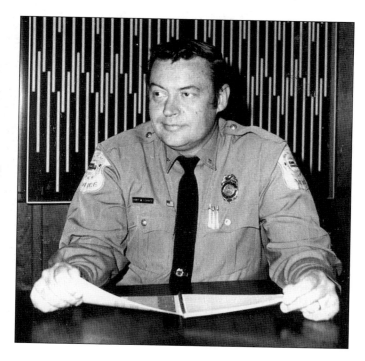

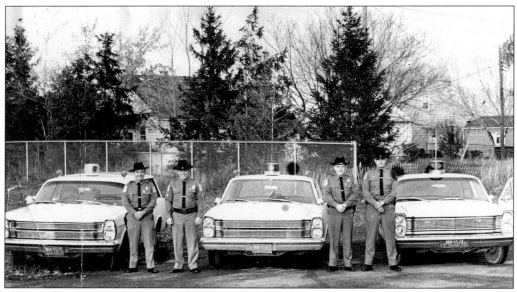

Gates police officers display the department's fleet in the mid-1960s. In the parking lot of the old town hall (at 1548 Buffalo Road) are, from left to right, Frank Chmylak, Gerald Thurley, William Gillette, and James Keltz. The police department headquarters was located on the lower level of the building.

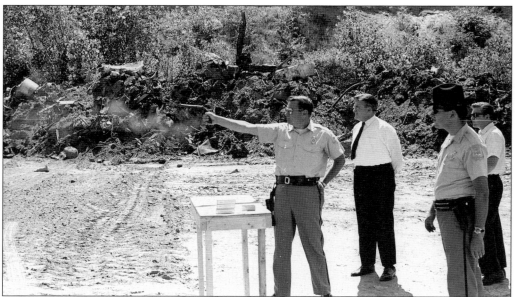

Chief William Stauber practices his aim in a gravel pit at Amico Brothers Construction Company, 4503 Lyell Road, in 1967. Among those looking on are Samuel J. Smith, editor and publisher of the *Gates-Chili News*, and police officer James Keltz. The Gates Police Department, as well as other law enforcement agencies, used the gravel pit as a target range in the late 1950s and early 1960s. At the time, the neighborhood was sparsely populated, and the pit had high dirt and gravel banks for safe shooting.

The Gates Police Department established a canine unit in 1980. Here, Chief Thomas J. Roche (left) and officer James Ayotte introduce the department's first police dog, Max.

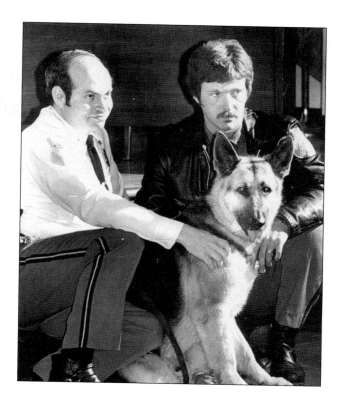

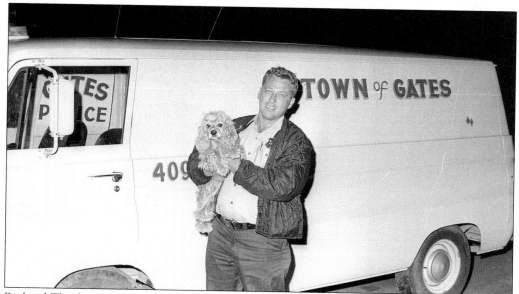

Richard Thurley, who served as Gates dog warden in 1967, is ready to return a canine friend to a waiting Gates household.

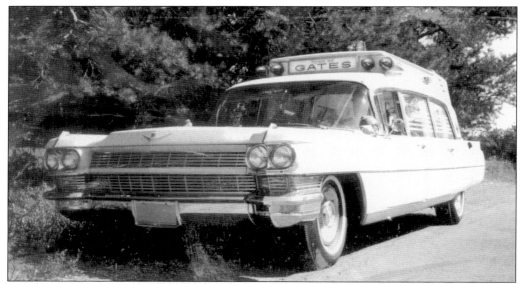

The Gates Volunteer Ambulance Service was founded on February 23, 1964, when the board of directors met to elect police chief William Stauber as its president and Dr. John F. Montione as vice president. The board purchased this Cadillac ambulance for $10,195. Emergency operations began on November 2, 1964, at 5:15 p.m., with a response to a motor vehicle accident on Chili Avenue.

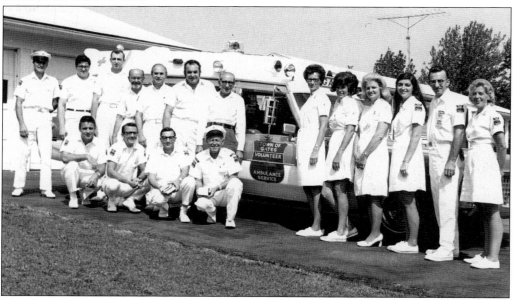

Members of the ambulance service gather in 1968 at the base of operations, then located at 144 Gatewood Avenue. From left to right are the following: (first row) James Hess, Don Butler, Anthony Federico, and director of operations Gordon Lindsay; (second row) deputy director of operations Robert Jacker, Donald Ioannone, Ronald O'Connor, Phillip Hockreiter, Cecil Karley, Duane Neu, Charles Vaccaro, Mary DeTamble, Dottie Koch, Ruthe Neu, Allison Kelly, Howard Mayer, and Lorna Butler. The service relocated to its present headquarters at 1600 Buffalo Road in March 1977.

Mary Rowena Pixley Harrington served as Gates town clerk from 1921 to 1949.

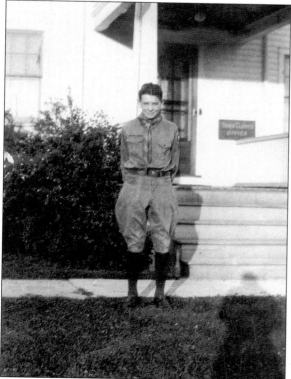

William Harrington dons his scout uniform outside his mother's home, on the east side of Wegman Road near Buffalo Road, c. 1930. His father, Charles A. Harrington, served as Gates town clerk and maintained the office in the original family home on Buffalo Road. Following Charles's death, his wife, Mary, was appointed to the post. The town clerks kept official records in their homes until 1940, when Lee's Tavern on Buffalo Road was purchased and renovated to become the first town hall.

Chester Field, father of Reuben Field, served as supervisor of the town of Gates from 1867 to 1871 and again in 1883.

John L. Pixley was supervisor of the town of Gates from 1872 to 1873.

Reuben L. Field, the son of Chester Field, served as supervisor of the town of Gates in 1876, from 1878 to 1880, and again in 1888.

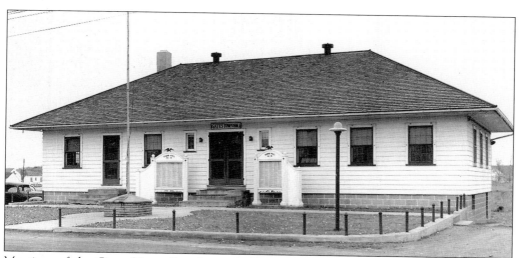

Meetings of the Gates Town Board were held in either the supervisors' or the town clerks' homes until 1940, when this town hall building was established. Town offices were on the first floor. The police department, justice court, and town meeting room occupied the lower level.

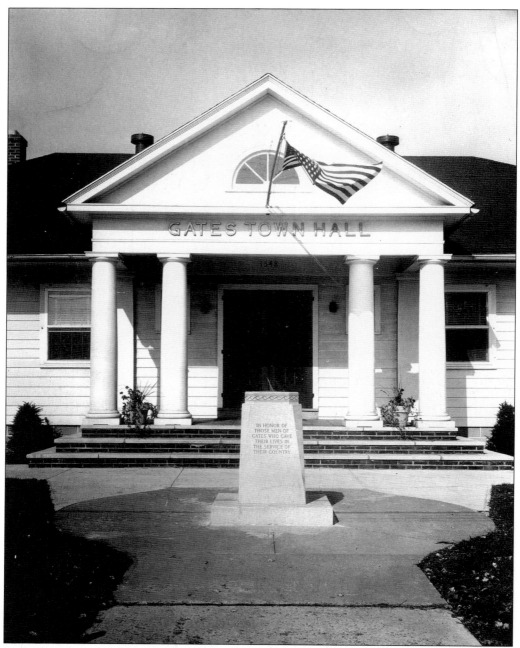

In the 1950s, a traditional public building façade and a veterans' memorial were added to the Gates Town Hall. In 1968, the monument was moved to the new Gates Community Center, a town hall, police department, and library complex at 1605 Buffalo Road.

Seven

COMMUNITY GROUPS

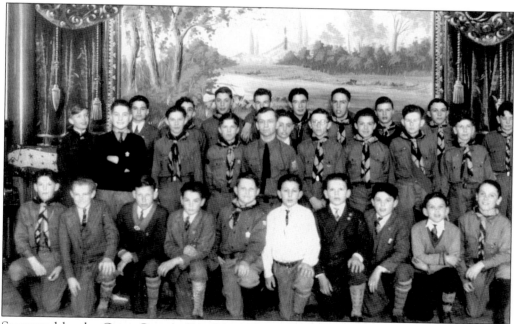

Sponsored by the Gates Grange, Boy Scout Troop No. 18 met in the Grange hall in 1930. Among those pictured are Frank Metcalf, Bob Lee, Bob Colburn, Fred Van Colt, Frank West, Armand Fink, Bill Schott, Bill Paddock, Cecil Westfall, Jay Statt, Russ Warrick, Chuck Carr, Paul Scott, Wally Wolfe, Chuck DeGrave, Ev Russell, Gene Field, Franklin Harrington, Glenn Warrick, and Bill Harrington.

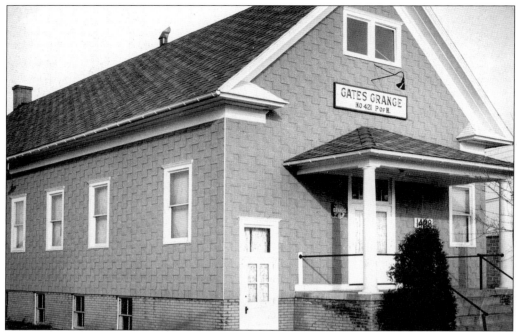

Gates Grange No. 421, Patrons of Husbandry, was organized on October 25, 1877. Its first headquarters was Union Hall, a two-story building (now Becker's Furniture) on Buffalo Road. In 1914, Reuben L. Field donated a lot diagonally across the road. Built by Frank C. Beaman, the new hall was nearly finished when it burned to the ground on the night of July 3, 1915. Grange members immediately set to work to rebuild the structure above, which stands today at 1408 Buffalo Road, just west of Crestwood Boulevard. In 1961, the building became the first home of the Gates Public Library and is Uniform Express today.

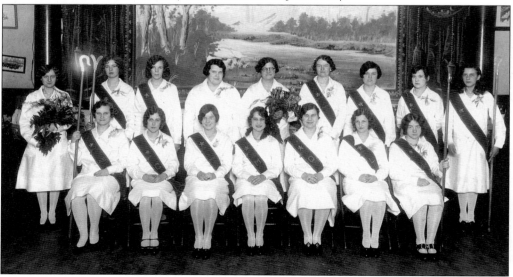

The women of the Gates Grange gather *c.* 1925. Among those pictured are Florence Kelly, Laura Burdick, Hazel Wilcox, Evelyn Salzer, Jean Dix, Hazel Ford Hancock, Louise Burdick, Mrs. Phillipson, Ada Caudle, and Ella Jackling.

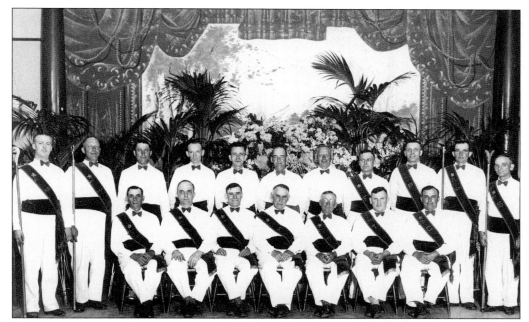

The men of the Gates Grange pose c. 1925. The Grange is the nation's oldest national agricultural organization. Since its founding in 1867 in Washington, D.C., it has grown to 3,600 local communities in 37 states with 300,000 members. Among those pictured are Floyd Bunn (fourth from the left, first row) and Oscar Hill (second from the left, second row).

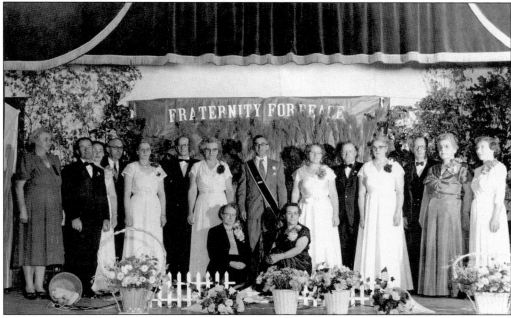

Forming a "fraternity for peace" in Gates in 1954 are, from left to right, the following: (first row) Bernice Peters and Vera Hobaker; (second row) Daisy Coffee, Henry Roberts, Marian Roberts, Raymond Peters, Alice Dentlinger, Lewis Tracy, Alice Baker, Grange master Fred Rauscher, unidentified, Elwyn Coman, Hazel Hill, Fred Coffee, Reah Tracey, and Mrs. Ernest.

These citizens identified themselves with the Temperance Union during the years of Prohibition. Samuel Jackling (1871–1954), who served as a Gates town official for 36 years, is seated in the front row on the left.

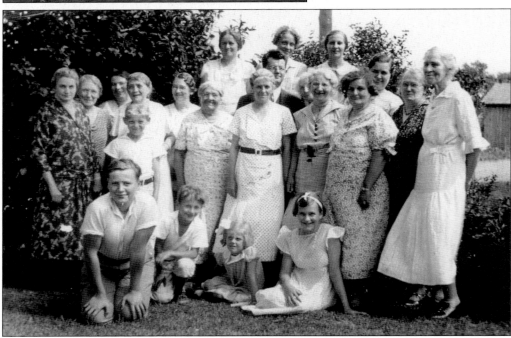

The Ladies Aid Society of the Gates Presbyterian Church picnic at Mrs. Bennett's home in Groveland.

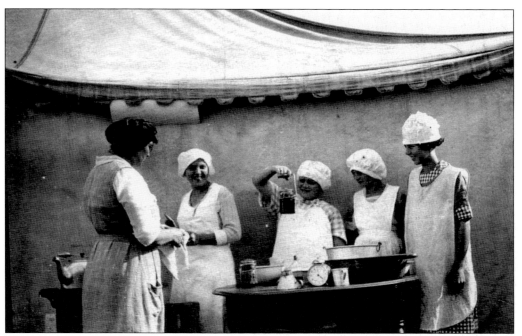

Women from the 4-H group Gates No. 1 demonstrate their canning skills at the Monroe County Fair *c.* 1924.

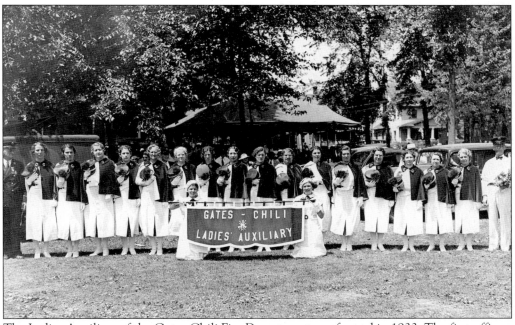

The Ladies Auxiliary of the Gates-Chili Fire Department was formed in 1933. The first officers were Maude Bohm, president; Helen French, vice president; Mae Link, secretary; and Emma Youngs, treasurer. Those identified in this photograph are Helen Bubel Jensen (third from the left) and Ida Buell Barrett (fifth from the left).

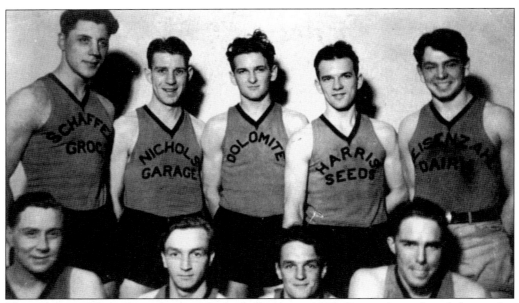

These young athletes formed a town basketball team *c*. 1932. Pictured are, from left to right, the following: (first row) Gene Robinson, Lloyd "Whitey" Roberts, Ebbie Roberts, and Jim McBurney; (second row) Ev Russell, Buss Erne, Marty Fink, Al Fink, and Bill Harrington. The shirts had a variety of names, according to Mr. Harrington, because each player solicited a local merchant to buy his shirt.

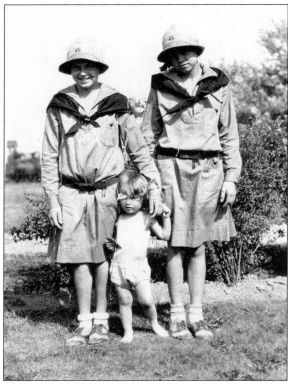

Janet (left) and Lillian Vowles were members of the Gates Girl Scout troop in 1930. Little sister Peggy was not yet old enough to join.

After 10 years of involvement with the Gates Little League, Harold "Hal" Pyritz established the Gates Lassie League for girls in 1958. It was the first Lassie League in New York State and the fifth in the nation. Pyritz's entire family participated. Pictured with Hal are, from left to right, Fran (his wife), Beverly, and Kathy.

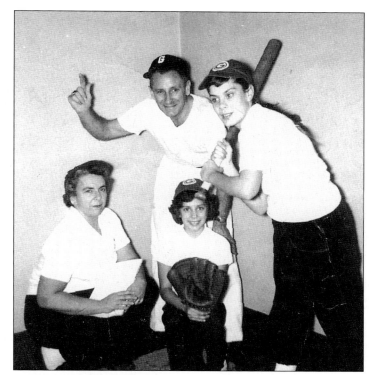

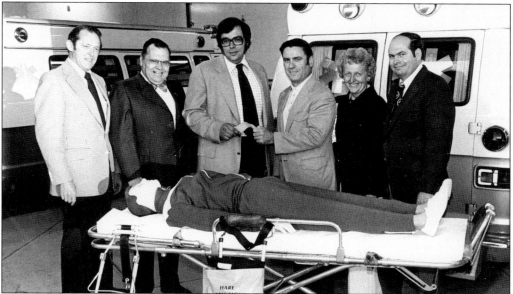

The Gates Lions Club has been a steadfast supporter of the community since its founding as the Gates-Chili Lions Club in 1950. Here, in the mid-1970s, Lions Horace "Buck" Holliday, Irv Wischmeyer, and Gerry Ride (first, second, and third from the left, respectively) present a donation of training and ambulance equipment to James J. Hess, director of operations of the Gates Volunteer Ambulance Service, as ambulance board members Eileen Vandermallie and Thomas J. Roche look on.

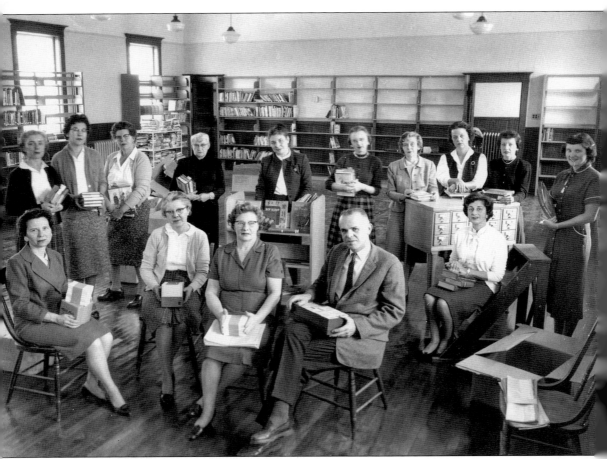

The town board established the Gates Public Library on November 11, 1959, with a budget of $15,000. A library board was appointed, and the former Gates Grange was leased as the first library. Operations began in January 1961. Pictured here are Charlotte York, Edna Kemp, Eleanor Freislich, and Ralph Johnston. They—along with Joseph Morrow (not pictured)—were the first library trustees. Standing behind the book truck is Madeline Wenkert, a consultant from the Monroe County Library System, who served as temporary head librarian. Also pictured are volunteers Ida Gould, Monica Hawkins, Lois Brownell, Nan Kipers, Phyllis Boysen, Gigi Wicks, Helen Van Strydonck, Ann Hall, Janet Beam, and Doris Kern.

Eight

SCHOOLS

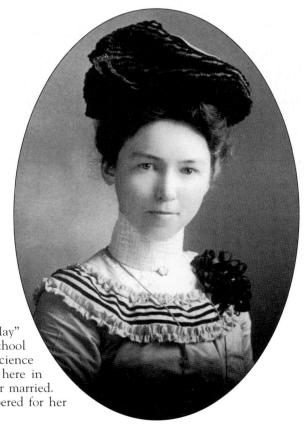

Born in the early 1870s, Mary E. "May" Dodd attended Brockport Normal School and became a schoolteacher at the Science Hill School on Manitou Road. Seen here in typical "schoolmarm" attire, she never married. A strict disciplinarian, she is remembered for her numerous spelling bees.

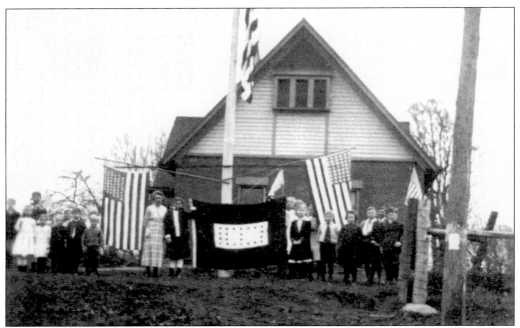

Students and teachers participate in a patriotic pageant on the front lawn of Common School District No. 1, at 2355 Chili Avenue, *c.* 1910. In 1931, residents voted to sell the schoolhouse to the Gates-Chili Fire Department for $2,000. Classes were relocated to the north side of Chili Avenue in a building known today as the Washington Irving School.

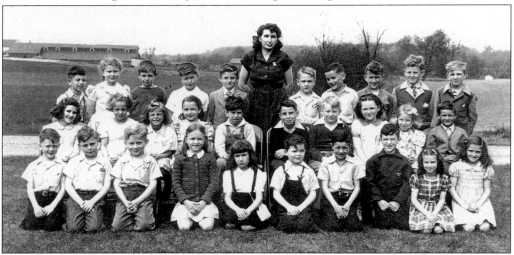

Shirley Bookman's 1946–1947 second-grade class poses in front of the Washington Irving School. From left to right are the following: (first row) Robbie Collamer, Jerry Bronson, Tommy Fahy, Carol Willits, Susie MacDonald, unidentified, Robert Sava, Jimmy Cooper, Dee Donohoe, and Sandy Kuhls; (second row) Susie Reid, two unidentified children, Lois Ackert, Jackie Miller, Walter Southworth, Harrison Kelly, Marilyn King, Melody Smith, and unidentified; (third row) Ronnie Holzschuh, Marylou Minoia, unidentified, Arnie Phillips, Russell Weaver, Mrs. Bookman, Gary Jermyn, Ronnie Phillippsen, Jimmy Ide, Barry Diehl, and Richard Maag.

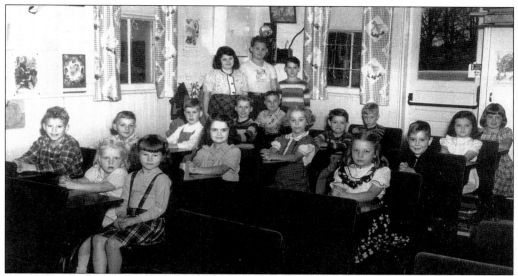

These youngsters attend Gates District No. 5 School, at the corner of Buffalo and Elmgrove Roads, in 1949–1950. District No. 5 is believed to be the earliest formally established school in Gates and was located on the northeast corner of Alexander Kenyon's farm.

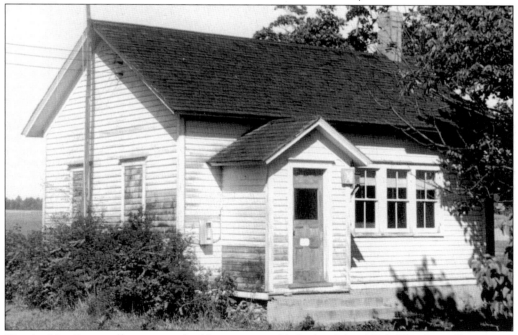

District No. 5, a small one-room building, was established in May 1824. The first officers were I. P. Fitch, moderator; Jonathan Kingsley, clerk; and James Merrill, William Jameson, Luke Hopkins, and Joshua Beaman, trustees. School was in session for three months a year beginning in December 1824. In 1874, the total school budget was $172.10, itemized as follows: $104. 60 for the teacher's salary, $40 for a stove, $25 for coal, and $2.50 for "incidentals." District No. 5 closed in 1953 with a balance on hand of $3,969.37, ending its 129-year history. Students transferred to Thomas Edison, and the old schoolhouse was demolished in 1961.

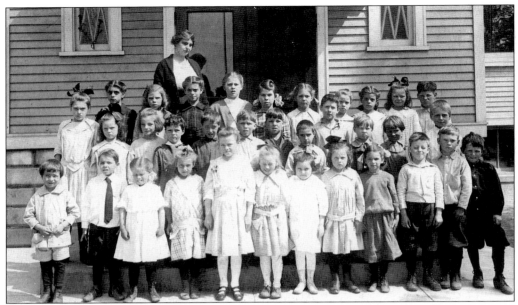

Students at District No. 7 School are pictured c. 1916. Aristine Jackling of Lyell Road appears somewhere in the first row. Her father, Samuel Jackling, a Gates town official for several decades, was elected school district clerk in 1906 and served in a variety of offices for more than 40 years. District No. 7 was renamed the Warren Harding School in 1925.

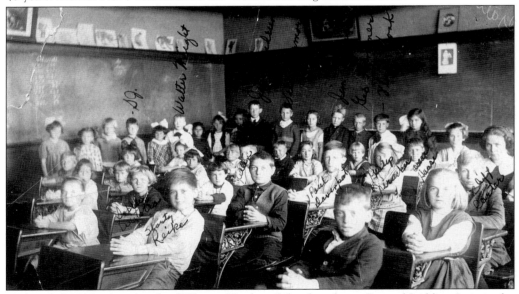

In this mid-1920s photograph of Warren Harding School students, Samuel Jackling Jr. is in the back row, fourth from the left. Originally known as Gates District No. 11 (later District No. 7), it was formed in 1827, when voters authorized construction of a schoolhouse at a cost not to exceed $150. In 1847, a second school was built, and a third in 1882. In 1925, voters approved construction of a brick building to be named in honor of Pres. Warren G. Harding. In 1953, the old frame building from 1882 was removed and new construction was joined to the 1925 brickwork to create an imposing façade.

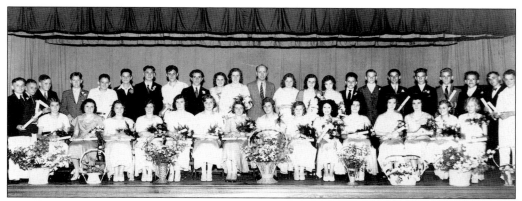

Warren Harding School graduating seniors pose in 1932. Included in the photograph are Margaret Dodd, Helen Carter, Dorothy Knight, Winifred Keenan, Eleanor Young, Mildred Woodson, Leona Roberts, Helen Allen, Dorothy Hosmer, Dorothy Graham, Eloise Wall, Robert Drake, William Smith, Glenn Wahl, Robert Fuller, Florence Schroth, Curtis Powers (school principal), Gertrude Drake, Jack Dyer, and Richard Fuller.

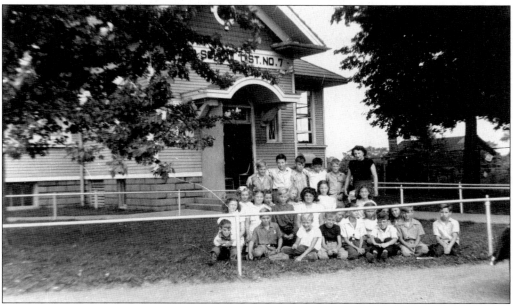

The students of Mrs. Monahan's fifth-grade class at the Warren Harding School pose in 1946. Included in the photograph are Richard Crockford, James Martin, Rita Geater, Wayne King, Doris Goss, John Johnson, Barb Thomas, Mildred Hammer, Ruth Doty, Jean Hill, Nicky Carderelli, Irene Slight, Larry Tobias, James Beebe, Charles Cervini, Donald Beebe, and Eugene Elmer.

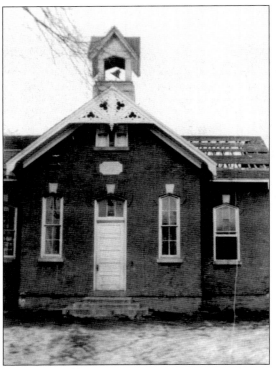

District No. 4, a one-room schoolhouse built in 1869 on the north side of Buffalo Road, just west of Howard Road, was later known as the Thomas Edison School. Earliest records date to 1837, although a school must have existed in the vicinity of Gates Center prior to that, because the business at the first recorded meeting was "to raise by tax $25.00 to repair the schoolhouse."

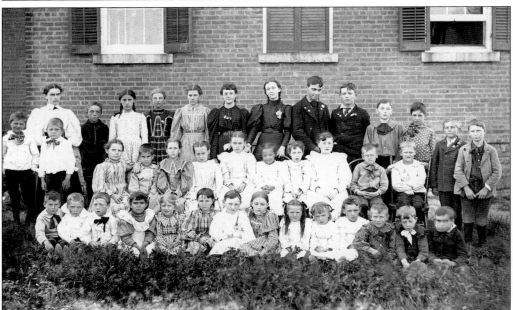

The students of District No. 4 pose for a group photograph with their teacher in 1896. The one-room red-brick schoolhouse was built at a cost of $2,000. The first trustees of the district were Eleazer Howard, Joseph Dewey, and Moses Gage. William Hinchey, Chester Field, and Reuben L. Field (Chester Field's son) also served as trustees in the mid- and late 1800s. The 1912 school budget was $900. Inside plumbing was installed in 1916.

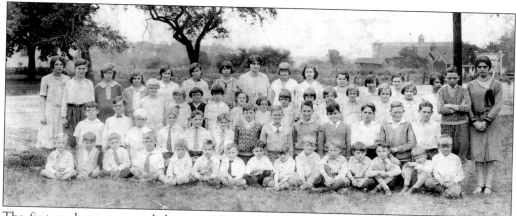

The first students to attend the new Thomas Edison School include, from left to right, the following: (first row) Mark Stenzel, Kenny Stiles, Harold Schott, Bob Irwin, unidentified, Simon Vowles, Louie Strassner, Don Schurr, David Briars, Bobby Ritter, Floyd Dill, Warren Dill, Edwin Metcalf, Edward Lilly, and unidentified; (second row) John Heffer, unidentified, Bob Johnson, Dick Charles, Billy Davidson, Chuck Vowles, Melvin Cowd, Don Kern, Bill Schott, Frank West, John Charles, George Cowd, and Frank Metcalf; (third row) Eleanor Roberts, unidentified, Peggy Jones, unidentified, Carol McCoy, Betty Hodder, Jane Erbach, unidentified, Sylvia Buttner, Betty Johnson, unidentified, and Charles DeNeef; (fourth row) Ruth Bieber (teacher), Wally Wolf, Bernice Davis, Helen Shay, Avis Luckett, Lillian Vowles, Doris Lilly, Marjorie Tabor (principal), Elizabeth Meyers, Norma Tucker, Mary Heffer, unidentified, Janet Vowles, unidentified, and Miss Carter (teacher).

Completed in January 1931 (on the 50th anniversary of the invention of the electric light bulb), the new District No. 4 school was renamed for Thomas A. Edison, who sent a letter of thanks. The letter was displayed for decades in the main foyer and was transferred to the Gates Public Library when Thomas Edison School closed due to declining enrollment in 1980. The building now houses Hope Hall, a school for at-risk or educationally stranded children.

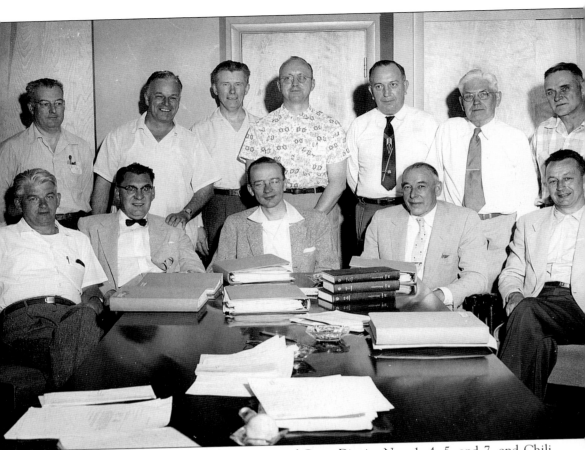

In 1955, voters approved the centralization of Gates District Nos. 1, 4, 5, and 7, and Chili District Nos. 2 and 11, and a year later approved the purchase of 86 acres on the east side of Wegman Road for a high school, administration building, and bus garage. At a cost of $3.6 million, construction began in June 1957. In September 1958, the facility was ready to accommodate students in the seventh, eighth, and ninth grades. Harold W. Beam was appointed the first principal of the Gates Chili High School. The members of the first Gates Chili Board of Education are shown here in 1956. From left to right are the following: (first row) Charles L. Lechner; Dr. Felix J. Balonek; Frank E. Holley, board president; Cecil W. Luffman, district principal; William J. Kirkmire, assistant district principal; (second row) Erwin M. Morris, board member and district clerk; Kenneth R. Kemp; Raymond E. Morris, school district attorney; Robert F. Zimmerman; Herbert J. Zimmer; George J. Peterson; and George C. Garnham.

Nine
CHURCHES

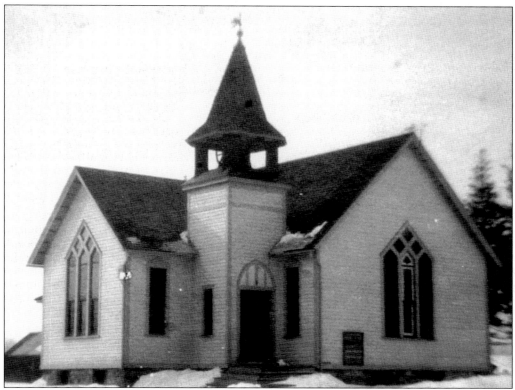

When the Elmgrove Methodist Church was established *c.* 1828, services were held in a log cabin schoolhouse on the southwest corner of Elmgrove and Spencerport Roads. In 1847, the church purchased the property for $30.68. A wood-frame building was constructed a year later. By 1875, the church had 20 members and had raised $500 through fund-raisers such as oyster suppers. In 1900, the original church was destroyed by fire. In 1904, a new church, seen here, was completed at a cost of about $2,000. The building stands today, though as a commercial business.

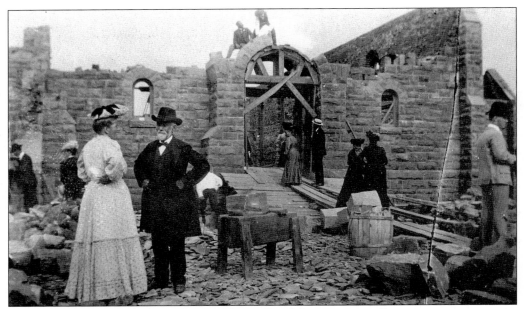

The Holy Ghost Church, located on Coldwater Road, began as a small mission to serve a group of German-speaking families of the Roman Catholic faith who lived in the hamlet of Coldwater. In 1875, the first brick church was constructed. In 1906, Rochester's first bishop, the Most Reverend Bernard J. McQuaid, dedicated the Medina stone Gothic church that stands today. Above, Mary Vogel and "Grandfather" Trabold attend the cornerstone ceremony c. 1904.

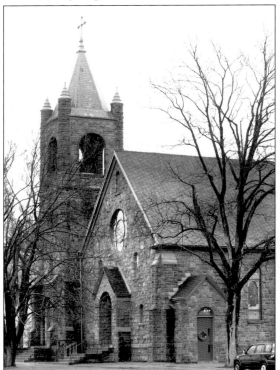

The Holy Ghost was officially organized as a parish on June 8, 1908. The Reverend Peter A. Erras was appointed resident pastor and served for 24 years. The Reverend Joseph C. Wurzer, then vice principal of the Aquinas Institute, succeeded him. During Father Wurzer's tenure, Joseph Entress, a community builder and lifelong parishioner, constructed the parish hall. In 1938, fire destroyed the Holy Ghost School. Ground was broken for a new school, dedicated by Bishop James E. Kearney, in 1939.

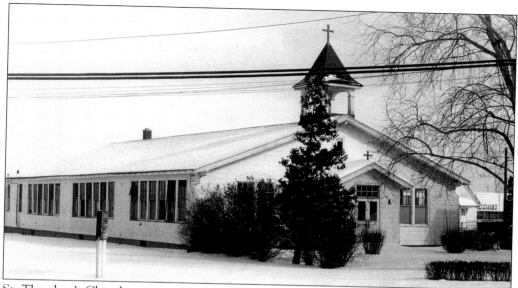

St. Theodore's Church was organized in 1924. The congregation held services at the Michael Kenney homestead at Lyell and Spencerport Roads until October 25, 1925, when the Most Reverend Thomas F. Hickey, bishop of Rochester, dedicated the above church. A wood-frame structure that also included three classrooms, it was built on four acres of the Kenney farm near the corner of Spencerport Road and Baier Drive.

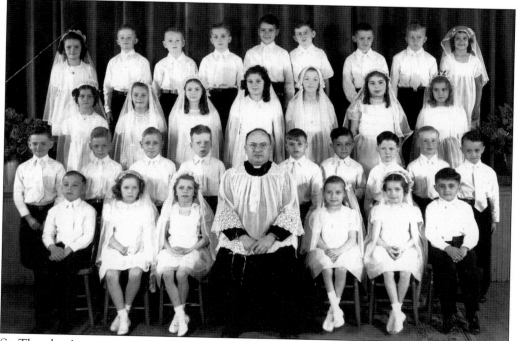

St. Theodore's presents its First Communion class in May 1945. Seated amongst the youngsters is the Reverend Raymond J. Epping, who succeeded Father Baier as pastor. Father Epping served from June 1937 until his retirement in 1960. Wilhemina Stadler sits to the right of Father Epping.

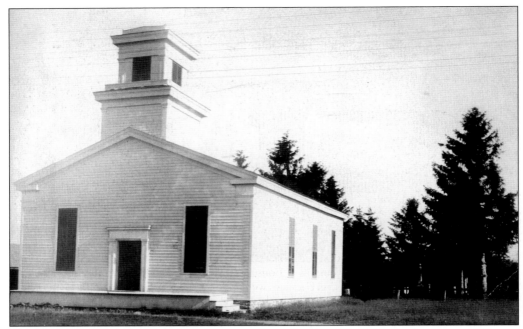

The Gates Presbyterian Church was organized on October 28, 1828, in the home of Eleazer Howard, on the southeast corner of Buffalo and Howard Roads. Pictured here is the first church, constructed in 1833 at a cost of $400 on the south side of Buffalo Road, just east of the intersection. Mr. Howard donated the land for the church and the adjoining cemetery.

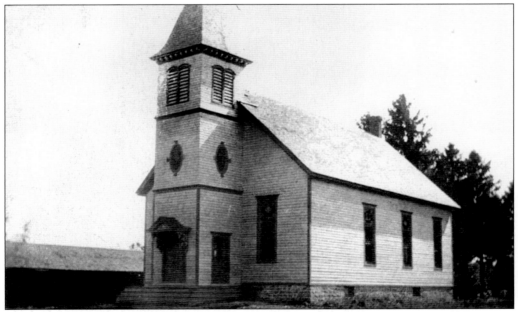

When the congregation outgrew the first Gates Presbyterian Church, a new $1,000 frame structure was built. Dedication services were held in 1845. Deacon Sperry constructed the adjacent sheds in 1854 at a cost of $180, and Franklin Hinchey donated a melodeon. The original church building was hauled away and converted into a private residence.

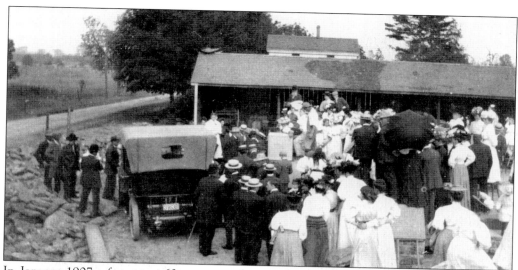

In January 1907, after some 60 years as a house of worship, the second Gates Presbyterian Church building was destroyed by fire. Services were held temporarily in the nearby Union Hall while rebuilding plans were made. Pictured in this eastward view, the cornerstone ceremony for the third church was held c. 1907. Buffalo Road, then unpaved, appears on the left.

The third Gates Presbyterian Church structure, dedicated in 1908, was built at a cost of $41,000. The cornerstone was drawn from the Munn farm on Pixley Road. Although the building is still standing on Buffalo Road, the congregation moved to a new church near the corner of Buffalo and Wegman Roads in 1963.

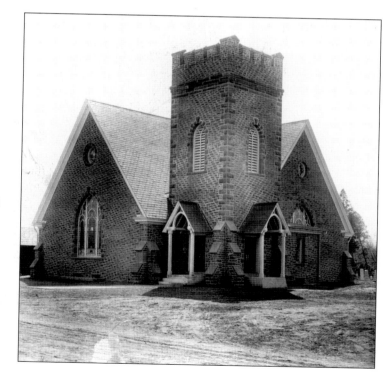

Gates Presbyterian Church Sunday school classes were separated by gender when this class of young men was photographed in 1913. Sunday school was originally held at the brick schoolhouse (District No. 7) or at the log schoolhouse just west of the church. Pictured here are, from left to right, the following: (first row) Fred Bonnet, James Sackett, Warren Kennel, and Walter Rypma; (second row) Raymond Daugherty, Reed George, Harold McCauley, George Harrington, and Harold Schott.

The congregation gathers outside the Gates Presbyterian Church following the dedication of the third sanctuary on May 12, 1908.

The Reverend John B. White served as pastor of the Gates Presbyterian Church from 1911 to 1928.

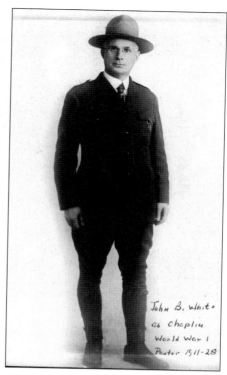

John B. White
as Chaplin
World War 1
Pastor 1911-28

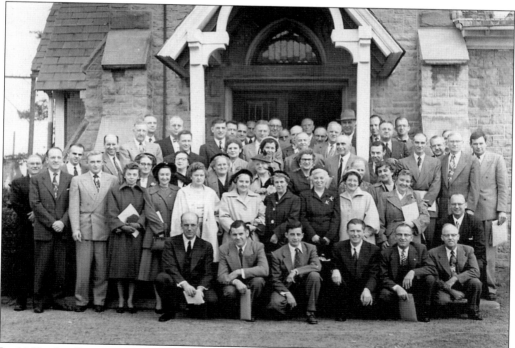

In 1952, the Gates Presbyterian Church organized canvassers to solicit contributions for an educational wing.

The first pastor of St. Helen's Church, on Hinchey Road, was the Reverend J. Beecher Sullivan (1905–1964). Ordained in 1929, he was appointed pastor by Bishop James E. Kearney when St. Helen's was established, on June 4, 1940.

The mission chapel of St. Helen's was organized on February 23, 1930, in a small frame building on Hinchey Road, then a sparsely settled section of Gates. An assistant priest from nearby St. Augustine's said a single Sunday mass each week. Following the 1940 establishment of the parish, the church grew quickly under the guidance of Father Sullivan and William J. Hickey and Fred C. Sours, the first trustees. During the inaugural year, a rectory was constructed and the Men's Club and Ladies Altar Society were formed. St. Helen's opened a small school in back of the church in September 1943. The church that stands today was dedicated in June 1962.

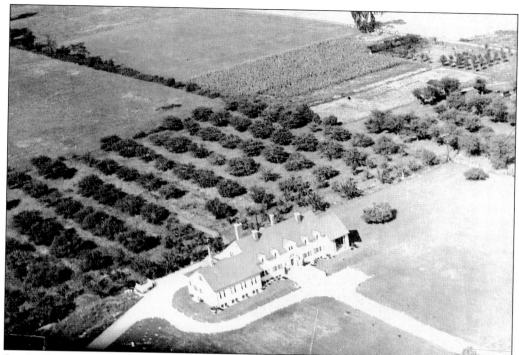

St. Andrew's Seminary was organized by the Most Reverend Bernard J. McQuaid, bishop of Rochester, in 1870 and was first located on Plymouth Avenue. The seminary prepared young men interested in the Roman Catholic priesthood for advanced study. Originally a day school, St. Andrew's began accepting boarding students in 1929 in Rochester. In 1937, Margaret Doud funded construction of the St. William's House as a student residence at 1150 Buffalo Road in Gates. When seminary enrollment increased, Bishop James E. Kearney and Monsignor Edward M. Lyons, rector of St. Andrew's, broke ground for a new seminary building, shown above and below, in 1948. Formal classes began in 1950. Today, the Buffalo Road campus is the headquarters of the Roman Catholic Diocese of Rochester.

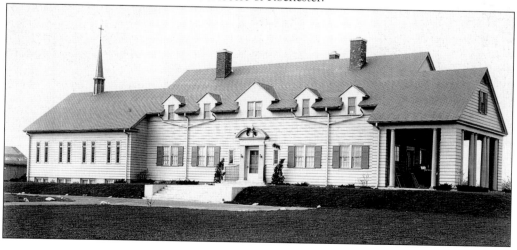

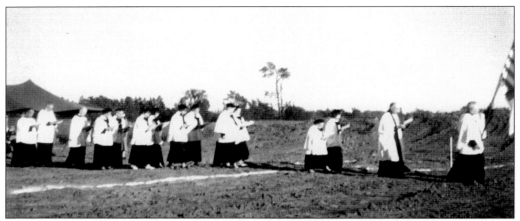

The Church of the Epiphany, founded as a mission of St. Luke's Episcopal Church in 1866, was formally organized as an independent congregation in 1876 with 170 families attending. In 1959, the Player Farm on Buffalo Road in Gates was purchased as the site for a new church. A procession, pictured above, was part of the groundbreaking ceremony on June 8, 1960. The first service in the new church, shown below, was held on Christmas Eve 1960. The Right Reverend Dudley Scott Stark, bishop of the Diocese of Rochester, dedicated the date stone on January 8, 1961, and the church building on March 26, 1961.

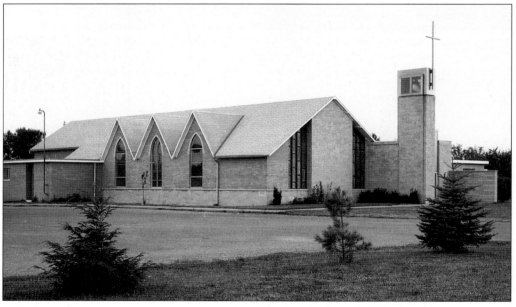

In June 1968, the Reverend John J. Steger, former assistant pastor at St. Theodore's Church, was appointed pastor of a new Roman Catholic parish to be established in west Gates. Following two weeks of balloting, parishioners democratically selected the name St. Jude the Apostle Church. The congregation purchased the Unger farm on Lyell Road and remodeled the old dairy barn (above) into the church building (below). The first service was held on November 1, 1968.

St. Jude's Church began the 1970s with the installation of an eight-foot-tall, hand-carved statue of St. Jude for an outdoor shrine. In 1973, ground was broken for a new parish center and rectory. Also in that year, the blessed traditions of the Solemn Novena to St. Jude and the St. Joseph's Table were established.

In May 1948, Mr. and Mrs. Louis Grammatico envisioned a church in north Gates. Following years of planning, the Christian Pentecostal Church, then occupying a building on Columbia Avenue in Rochester, was relocated to 4095 Lyell Road in Gates. Ground was broken in March 1969, the first service was held on July 19, and the church was dedicated on September 20. In the mid-1970s, the church's name was changed to the Gates Assembly of God. The Reverend Joseph Mignano and his wife, Rose, led the church until their retirement in 1997.

Ten
PEOPLE AND PLACES

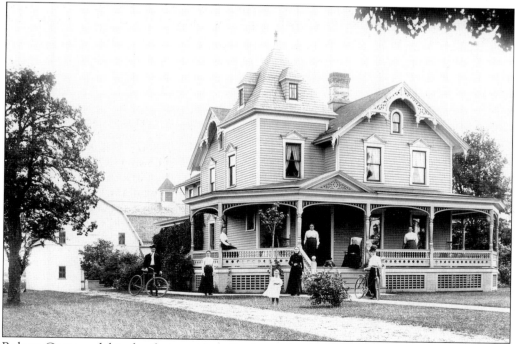

Robert Curry and his family moved to Rochester in 1825 and settled in Gates in 1834. Although no longer standing, their homestead at 995 Buffalo Road was a grand structure, as seen above c. 1872. This is now the site of the Gates Motel.

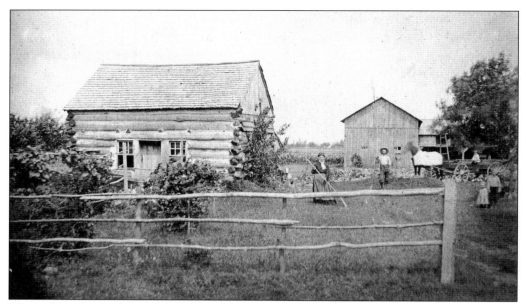

These photographs depict the early and later stages of a homesteader's progress. Elizabeth and Gottfried Sauer settled in Gates c. 1865. In the above photograph, taken c. 1870, they are pictured with their three children—William, Catherine, and Annie—at the family homestead on the north side of Lyell Road, west of the intersection with Wegman Road. The family's success is shown in the below photograph, in which Elizabeth Sauer stands outside their new home in 1895.

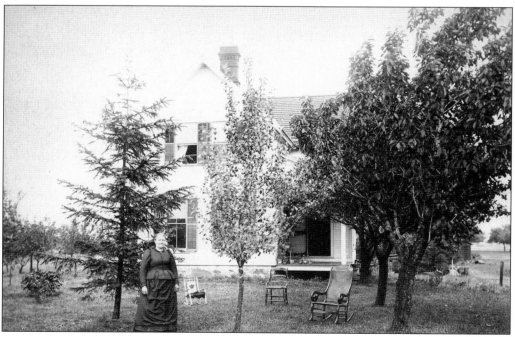

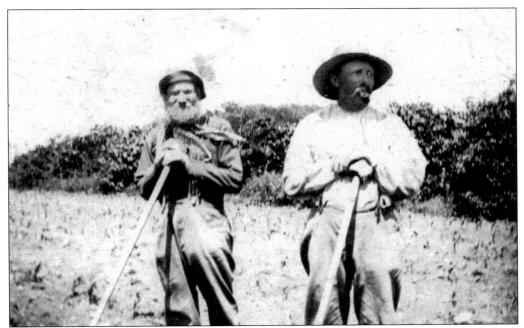

Gottfried Sauer (left) and Thomas Roe were farming in the late 1800s. Historic maps of Gates show that the Roe family lived on the east side of Wegman Road, opposite the lime kiln operation and about where the Gates Chili High School and bus garage are today.

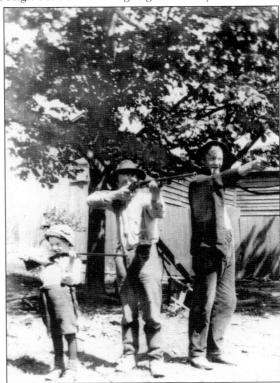

Al Sauer (right), the grandson of Gottfried Sauer, and two young shooters take target practice at the Sauer farm on Lyell Road in 1916.

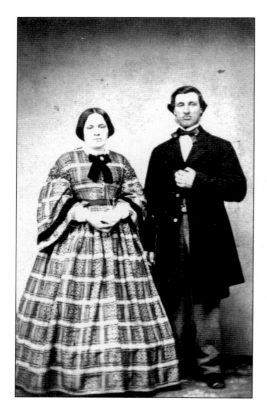

Eliza May Harder, aged 32 in 1870, and Thomas Jerry, 35, lived on the Harder homestead, near the northeast corner of Chili Avenue and Howard Road, now the site of Wal-Mart. Eliza's parents, Mary Ann and Samuel Harder, purchased the 4,000-acre tract in 1837 for $150. They originally lived in a log cabin and frequently found Native Americans at their door. In 1851, they built a 25-room homestead on the present Wal-Mart site. Their great-grandson Roy Wilcox operated the first gas station in south Gates, on the corner of Chili Avenue and Beahan Road (see page 39).

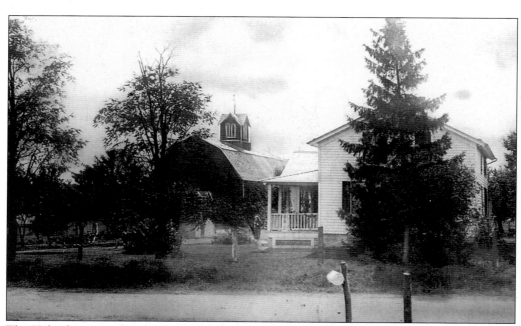

The Kuhn homestead and cider mill were located on the south side of Lyell Avenue opposite Lee Road, known at the time as Lee Road Extension. The home was demolished in the 1960s.

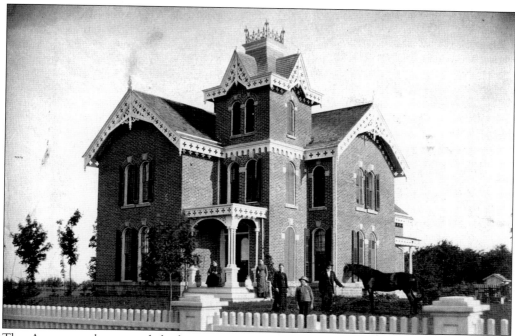

The Armstrong homestead, built in 1875, was located on the north side of Buffalo Road, approximately where Abbott's Frozen Custard stands today. The family photograph below includes Charles and Diana Chase Armstrong and their children—Mary, Elizabeth, Ida, Frank, and Ella.

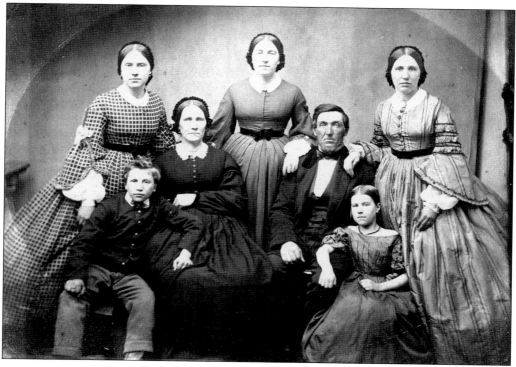

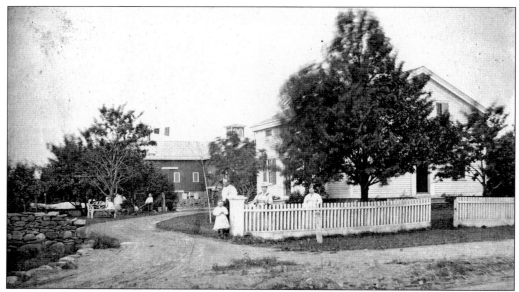

The Curtis homestead was located on the south side of Lyell Road, west of the intersection with Wegman Road, and opposite the Sauer farm. Annie J. Sauer (right) lived from 1852 to 1879. A life span of 37 years was not uncommon in the 1800s.

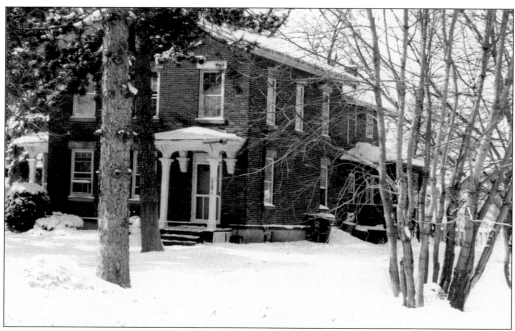

Adam and Julia Statt settled in Gates in 1838. This brick house, which still stands at 1781 Long Pond Road, was the home of their son John. The Statts operated a dairy farm.

Chester Field owned considerable acreage in the area of Gates Center and opened a hotel on Buffalo Road in 1832. In 1875, his son Reuben purchased the Booth home, seen here, on the north side of Buffalo Road, just east of the intersection with Howard Road. Reuben's daughter Mary married Frank Chase and lived here, as well. The house, remaining today as a commercial enterprise, is alternately known as the Field house or the Chase house, depending on how far back one remembers.

Mary and Aristine Field, pictured in their Sunday best, were the daughters of Reuben and Ella Armstrong Field. After Aristine married Martin Dodd, the couple lived on Lyell Road near the Sauer homestead, where they raised seven daughters. Mary Field married Frank Chase, who lived on Buffalo Road about a half-mile from the Fields. They had one daughter, Frances.

The Vogel and Trabold names are well known in Gates. This formal studio wedding photograph of Joseph Vogel and Mary Trabold was taken c. 1884. Pictured here, from left to right, are the following: (first row) Regina Trabold, Joseph Vogel, Mary Trabold Vogel, and an unidentified family member; (second row) George Trabold, Anne Trabold Vogel, Casper Vogel, and Anthony Vogel. Joseph, Casper, and Anthony Vogel were the sons of William and Ephony Vogel.

In 1880, the Chase family included John L. Chase; his wife, Anna; and children Clara and Frank. Their homestead at 1758 Buffalo Road still stands today. Clara, who never married, lived in the homestead all her life. Frank married Mary Field and lived with her parents, Reuben and Ella Field, in the Field home on Buffalo Road in Gates Center.

Aristine Pixley Munn (1817–1918), pictured here, married Edwin G. Munn in 1834. They had two children—Frances Emily Munn Field and Dr. John Pixley Munn. Her son became president of the U.S. Life Insurance Company in 1902, and he served as a trustee of the University of Rochester from 1886 until his death in 1931. Aristine Pixley Munn donated land for the Women's College at the University of Rochester. She was a member of the Society of Mayflower Descendants by right of descent from Gov. William Bradford.

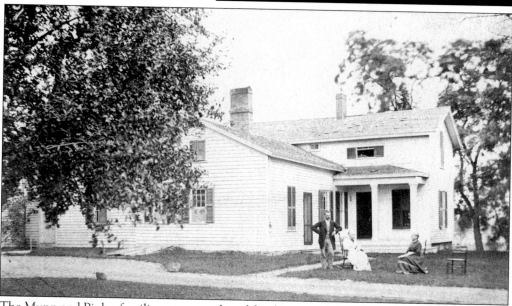

The Munn and Pixley families are remembered for their operation of the Munn farm, their work as physicians, and an affiliation with the University of Rochester. The homestead was located on Pixley Road at the high point of the rise between the railroad crossing and Buffalo Road. This was known as Paradise Hill, and table grapes were the main cash crop of the farm. In the early 1900s, they began to board and train horses under the name Old Elm Stock Farms. The horse track was located just off Buffalo Road, approximately where Westmar Plaza is today.

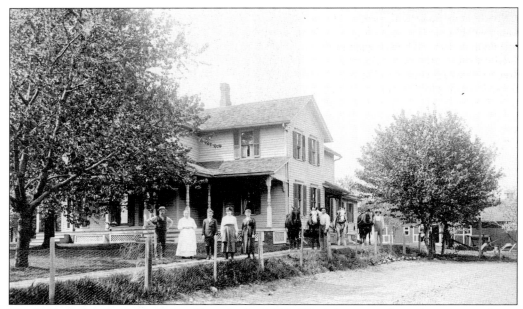

The DeRuyscher family settled in Gates in the 1880s. Their homestead stood on the northeast corner of Long Pond and Spencerport Roads, the site of the former Bosdyk's Restaurant. William DeRuyscher served as a part-time town constable in the 1940s.

The DeRuyscher family c. 1910 included Isaac Sr., Mary, and their nine children: (first row) Jean, William, and Mary; (second row) Isaac Jr., Abraham, Susie, Peter, Jacob, and John.

Nellie Caudle poses with her daughters Hazel, Ada (standing), and Pearl c. 1915. The Caudle family lived on the south side of Buffalo Road, just west of the present-day Gates Community Center.

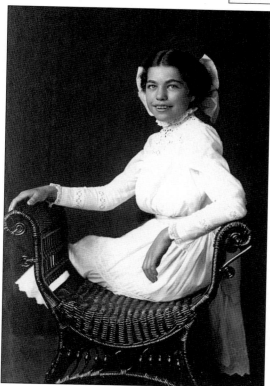

Henrietta Schott Charles worked as a hairdresser from the mid-1930s to the early 1980s. Her shop was in the enclosed front porch of her home on Buffalo Road, making for a fairly short commute.

Arriving in Monroe County in the 1830s, the Metcalf family established a homestead and pig farm at 1096 Buffalo Road. Benjamin Metcalf served as the town supervisor from 1918 to 1933. He and his wife, Maude, had two sons—Arnold and Edward. The home pictured above in 1903 stands today next to the 390 Expressway, and this former pig farm is now the Pig-Pen Mini Storage and Power Pig Mobil Wash.

Arnold Metcalf Sr. tends to his favorite horse. The Metcalf barn burned in the early 1900s.

The members of the Jackling family were early and active citizens in Gates. Residents in the homestead at 2232 Lyell Road in 1920 were Samuel J. Jackling; his wife, Ida Stone Jackling; and their children: Gertrude, 18; Roy, 17; Clara, 16; Ella, 14; Aristine, 12; Ruth, 11; Arthur, 9; and Samuel, 4. Samuel immigrated to the United States from England in 1874 at the age of three. The family then settled in Gates in 1880. He operated his 60-acre fruit farm on Lyell Road for more than a half-century and served as a town official for a total of 36 years—24 as justice of the peace and 12 as welfare officer.

Ida Jackling and her sister Mabel Miller often took the bus to go fishing. Here, they display a day's catch after the return bus trip. No word is available on what their fellow passengers thought of their cargo.

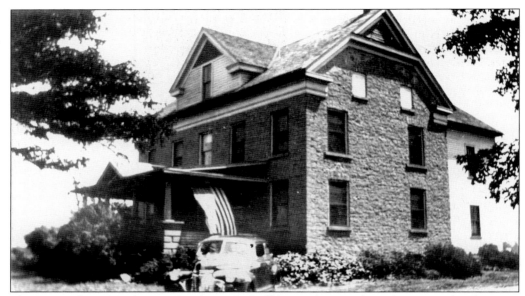

The Bonnet homestead was situated at 1151 Buffalo Road, across from the current headquarters of the Roman Catholic Diocese of Rochester. In the 1930s and 1940s, it was known as the Dolomite House. When this photograph was taken, *c.* 1942, the home had been converted into apartments. George Ebert, Arnold Metcalf, Ann Merritt, and Lloyd Roberts were among the renters in 1942. The homestead was demolished in 1950, when the Dolomite gravel pit was enlarged.

Among the nurses from Gates who provided "tender loving care" were Agatha Entress, Verena Jacobs, Catherine Styneer, Juletta Statt Resch, and Florence Knoepfler Clotier.

Dan Sweichard sits defiantly in front of his home *c.* 1917 in Rochester's Dutchtown neighborhood, then part of Gates. He lived in the Grape House, previously owned by Gen. Elwell Otis. Mr. Sweichard was interviewed for the local newspaper about his concerns that the city of Rochester was annexing parts of Gates. His neighborhood eventually became part of the city. During the 1800s and continuing to 1919, a number of annexations by the city of Rochester gradually reduced the town of Gates to its present size of 15 square miles, the smallest town in Monroe County in land area. (Courtesy of the Albert R. Stone Collection, Rochester Museum and Science Center.)

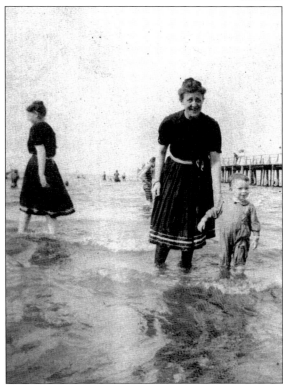

Little Franklin Hinchey and his mother, Ellen, enjoy wading in Lake Ontario at Sea Breeze in 1907. One had to be well covered for a swimming adventure in those days.

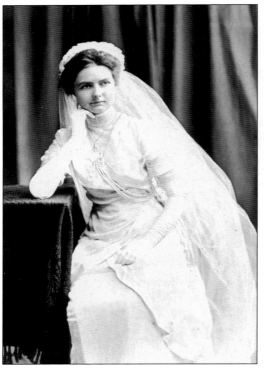

Delia Weeks appears in her formal wedding photograph. She was the daughter of the Reverend Frank G. Weeks and Myrtie Beaman Weeks. He was the first resident pastor of the Gates Presbyterian Church.

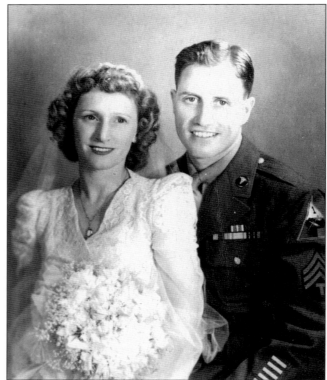

Harold and Vi Wood got married in March 1945. Harold is remembered for his service as an active member of the Gates Lions Club and his career as a funeral director at the Harold F. Wood Funeral Home on Buffalo Road near Howard Road.

Aristine Jackling (right) married Leon Edward Dool of Scottsville, New York, in 1928. Her wedding photographs include this one, with her sister Ruth.

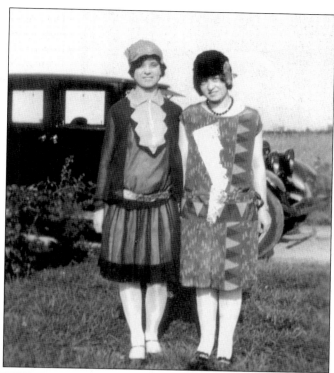

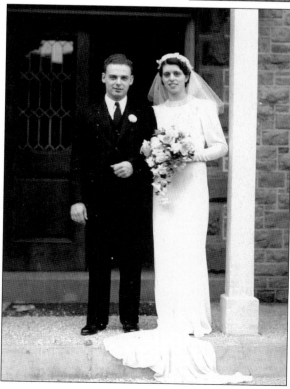

Edwin Pixley and Eugenia Carter pose outside the Gates Presbyterian Church on their wedding day in 1937.

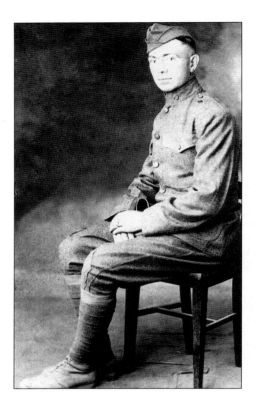

John Schott served in World War I in Company K, 347th Infantry. He entered the service as a private in July 1918, served overseas until December, and was discharged in January 1919.

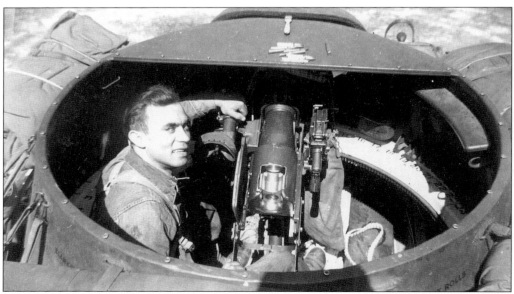

Cecil J. Karley fought in World War II in the 3rd Cavalry Reconnaissance Squadron, known as Patton's Ghost Troops. He was wounded in November 1944 during the liberation of Luxembourg when a bouncing betty land mine exploded. A life member of the Gates Volunteer Ambulance Service, Mr. Karley is the only Gates resident to have received the outstanding citizen award from both the Gates Lions Club and the Gates-Chili Chamber of Commerce.

Eugene Redick served in the U.S. Navy during World War II, from 1944 to 1946, in the North Atlantic on the *J. Fred Talbot*.

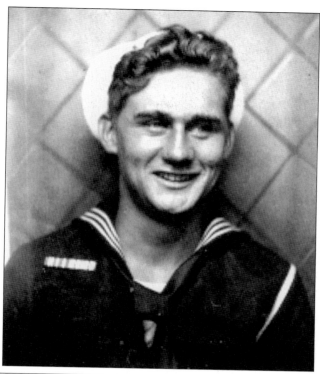

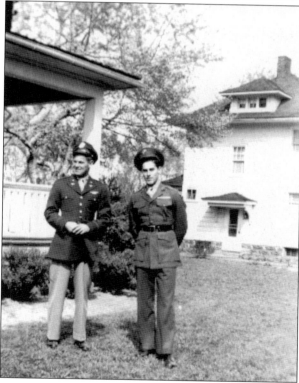

Charles (left) and Simon "Toppy" Vowles served from 1943 to 1945 (Simon in the U.S. Marine Corps and Charles in the U.S. Air Force). This photograph was taken in front of their house at 1004 Buffalo Road during the only time they were both home on leave.

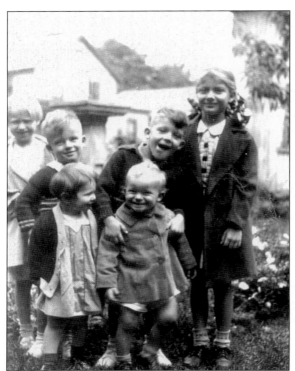

Gathering on the Hinchey Homestead in the mid-1930s are the Hinchey children and their cousins visiting from Ohio. In the front row are Doris Dix and Peter Hinchey. In the back row are Juanita Dix, Ronald Hinchey, Bill Hinchey, and Barb Hinchey.

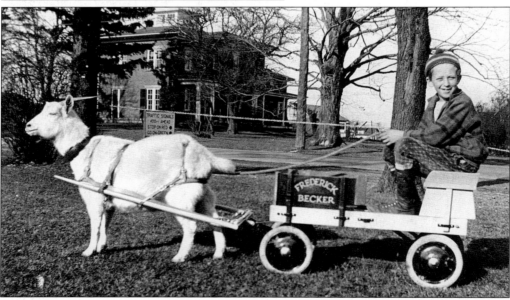

Fred Becker, the son of Becker's Market founder Frederick Becker, heads west in his goat-powered wagon at his home on Buffalo Road. The Reuben L. Field house, still standing today, appears in the background. The road sign hanging from a chain strung between two trees warns motorists of the new technology at the intersection of Buffalo and Howard Roads. It reads, "Traffic Signals / 400 Ft. Ahead / Stop On Red / Go On Green." The sign did not face the drivers; they had to take their eyes off the road to see it.

Ella Armstrong Field (1852–1935) was the second wife of Reuben L. Field. They married on September 22, 1880, and had three children—Mary, Aristine, and Chester. Ella can be seen as a little girl on page 111.

ACKNOWLEDGMENTS

The Gates Historical Society gratefully acknowledges the many individuals, businesses, and civic groups who answered the call for loans of historic photographs of Gates, the last remnant of the old town of Northampton on the west side of Monroe County. With the community's support, more than 500 photographs were submitted.

Special thanks go to Steve Shanker, who scanned most of the photographs, along with Patty Uttaro and Jean Kohlhoff. Without their technical expertise, this book would not have been possible. The society is grateful for their long hours of volunteer effort.

Kudos also go to the captions committee, under the able leadership of John Robortella and composed of Frank Roberts, Mickey Schlosser, June Thomas, and Janet Vowles. The committee's accuracy and work on the text and the chapter layout was vital.

Mickey Schlosser, who managed the receipt and return of the loaned photographs, deserves special mention for her superior organizational skills.

Many thanks go to committee members Ken Beaman, Judy DeRooy, Jean Kohlhoff, and Regis Mooney, who gathered many of the images. Susan Swanton, committee chairperson and founding president of the Gates Historical Society, was the visionary who coordinated this year-long effort. The committee met twice a month, and sometimes more frequently, at the Hinchey Homestead, the historic site now managed by the society and owned by the town.

Finally, this book could not have been published without the support of Laura Nolan, the president of the Gates Historical Society, and the board of directors.

A tip of the hat goes to our neighbor to the west, the town of Ogden, whose publication *Spencerport and Ogden* was the inspiration for this project. Arcadia Publishing, especially Pam O'Neil, provided wonderful aids to help us and was as close as an e-mail for consultation.

May other small historical societies take heart from the outpouring of public response to our call for vintage photographs, from the talented volunteers who stepped forward, and from the assistance of Arcadia Publishing. This clearly exemplifies the phrase "Build it and they will come."